THE GRAVESIDE ORATIONS
OF
CARL EINSTEIN

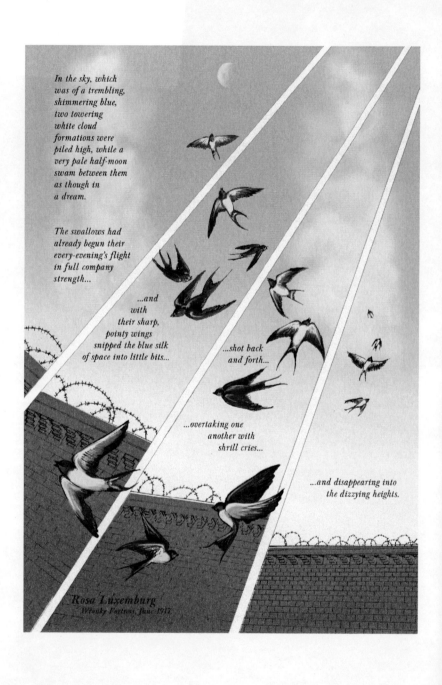

In the sky, which was of a trembling, shimmering blue, two towering white cloud formations were piled high, while a very pale half-moon swam between them as though in a dream.

The swallows had already begun their every-evening's flight in full company strength...

...and with their sharp, pointy wings snipped the blue silk of space into little bits...

...shot back and forth...

...overtaking one another with shrill cries...

...and disappearing into the dizzying heights.

Rosa Luxemburg
— *Wronke Fortress, June 1917*

THE GRAVESIDE ORATIONS
OF
CARL EINSTEIN

Edited by
Dale Holmes
&
Sharon Kivland

MA BIBLIOTHÈQUE

EDITORS: DALE HOLMES & SHARON KIVLAND

EDITORIAL ASSISTANT: JULIETTE PÉPIN

THE GRAVESIDE ORATIONS OF CARL EINSTEIN

MA BIBLIOTHÈQUE, LONDON
All rights reserved. Published 2019
Printed by Scantech, Hastings, Great Britain
Set in Didot, Linotype Didot, Bodoni

ISBN 978-1-910055-60-1

Cover: David Mabb, *Construct 63 (Graveside Oration for Rosa Luxemburg: Morris,
Golden Lily / Malevich, Suprematist Composition)*, 2006
Acrylic on wallpaper mounted on linen, 558.8 mm x 558.8 mm. Courtesy of the artist

Frontispiece: Kate Evans, from *Red Rosa: a graphic biography of Rosa Luxemburg*,
London: Verso Books 2015. Courtesy of the artist

Page 137: Extract from Jeroen van Dongen, 'Mistaken Identity and Mirror
Images: Albert and Carl Einstein, Leiden and Berlin, Relativity and Revolution',
Physics in Perspective, 14 (2012), 126–77.

One does not remain passively separate from reality
but rather constructs a new reality.

　Carl Einstein

You know that I really hope to die at my post, in a street fight
or in prison. But my innermost personality belongs more
to my tomtits than to the 'comrades'.

　Rosa Luxemburg

CONTENTS

PREFACE & ACKNOWLEDGEMENTS 11
Dale Holmes

BODY, GRAVE, MOURNERS 15
Dale Holmes

CRUD 21
Sean Ashton

CHAPTER NINETEEN 22
Hannes Bajohr

HERR EINSTEIN 23
Rowan Bailey

A LETTER IN THE STORM 24
Sean Bonney & Sacha Kahir

WIDENING CIRCLES 27
Uma Breakdown

GRAVESIDE ORATION: FOR SEATED SOLO SINGER 28
AND ANSWERING, MOVING CHORUS
Matthew Burbidge

UNTITLED 29
Sonja Burbidge

SOME THOUGHTS ON ANTI-FASCISM NOW 30
Sophie Carapetian

LUMINOUS ROSA 34
Alison J. Carr

IS THIS THE LAST TIME? 35
Declan Clarke

LET ME TELL YOU A STORY... 36
Kirsten Cooke

HISTORICAL BLANK: THE LOST EULOGY OF CARL EINSTEIN 41
John Cunningham

STYCZEŃ / JANUAR / JANUARY 51
Mark Curran

THE TRANSFORMATION OF THE REAL 53
James Davies

ZEEZEEBEY 54
Sam Dolbear

FAREWELL BLUE TIGER 56
Donal Fitzpatrick

WHO AM I TO SPEAK ON BEHALF OF THE DEAD? 59
Darryl Georgiou & Rebekah Tolley-Georgiou

ROSA! SOAR, ROSA! 60
Derek Horton

MY DEAREST ROSA 64
John Hyatt

TAKE A MOMENT FOR YOURSELF 65
Martin Jackson

38 SENTENCES FOR ROSA LUXEMBURG 69
Tom Jenks

FORMS GROW RAMPANT: A NO GOD'S EYE VIEW 71
OF EINSTEIN'S GRAVESIDE ORATION FOR ROSA
Sacha Kahir

BOUQUET 77
Sharon Kivland

AN ADDRESS TO THE LIVING ON THE EVE OF THE 79
FIRST CENTENARY OF THE SPARTAKIST UPRISING
Pil & Galia Kollectiv

CANALS 2018 83
John Z. Komurki

WHAT DID HE DO WITH HIS PIPE? 87
Mark Leahy

'AND NOW, IN ALL SERIOUSNESS, A KISS. YOUR R.' 91
Rona Lorimer

EIN STEIN IN MITTEN VON ZEHN GRÄBERN 95
Katharina Ludwig

A EULOGY FOR ROSA 98
Ed Luker

AS IT WAS, I HAVE A PROBLEM WITH AS IT WAS 100
T.C. McCormack

ORATING THIS ORATION 105
Martina Mullaney

A LOVE LETTER TO ANDRE LANCASTER 106
Nick Hadikwa Mwaluko

WAKE, ROSA 112
Benjamin Noys

THE GRAVE 115
Betsy Porritt

59275 118
Bede Robinson

ROSA WAS OUR FUTURE, AND NOW WE ARE HERE 119
Louis-Georges Schwartz

DARSTELLUNG, LUX 121
NOTES TOWARD A SUPREME FRICTION
Benjamin Seymour

ANTI-SENTIMENTAL LOVE 128
Ohad Ben Shimon

WRITING WITH A PEN THAT IS NOT IN YOUR HAND 131
Joshua Simon

A ROSE FOR ROSA 134
Zoë Skoulding

GRAVEDIGGERS 135
David Steans

WHAT DR EINSTEIN? 136
Jeroen Van Dongen

AN ORDINARY MOURNING 140
Frank Wasser

'THE LANDWEHRKANAL WILL NOT STOP' 144
Geoffrey Wildanger

EINSTEINROSARAUSCHEN 147
Christian A. Wollin

DEAR ROSA 149
Sarah Wood

LOVE AMONG THE SAILORS / DON'T ASK ME FOR WORDS 152
(LAURIE ANDERSON // EUGENIO MONTALE)
Thomas Yeomans

AFTERWORD
SPARTAKUSBRIEFE (GELBE WESTEN) 1 16/11/18–6/12/18
Spartakus 154

PREFACE

The first sign of a massage for the royalists: the mishaps of Liebknecht and Rosa Luxemburg. This showed once again that the best ideas readily succumb to a Prussian rifle butt. [1]

I

CARL EINSTEIN (1885–1940) WAS A WRITER, art critic, contrarian, and political radical who left his mark on the major developments of the early twentieth century. In January 1919 he was in Berlin. Over a decade earlier he had arrived on Berlin's literary and art scene with the publication of his expressionist novel *Bebuquin or The Dilettentes Of The Miracle* (1905). Through his lectures and writing he critiqued the development of cubist painting, focussing on its extreme heterogeneity, in opposition to the contemporary apologies that cubism was an art of ideation and synthesis. Like many in Berlin's creative community he had volunteered for military service at the start of World War I. Posted to Brussels in 1914, by the November of that year he had sustained a serious head injury. While convalescing he constructed his ground-breaking book on African art, *Negerplastik* (1915), positing an anti-imperialist, anti-evolutionary, and anti-racist reading of African sculpture which ran counter to contemporary accepted narratives and intellectual trends. In 1917 he was back at the front; injured again and traumatised, he was demobbed, and denounced by the German military for his political radicalism. He was an active participant in the political turbulence that characterised Berlin in the wake of the war. Involved in the 'November Revolution' in Brussels and the Revolutionary Soldiers Council in Berlin, he and his wife, Maria Ramm, were arrested for their part in the Spartacist Uprisings of January 1919.

On 15 January 1919 Rosa Luxemburg was murdered along with Karl Liebknecht by German *Freikorps* officers. Their murders were not spontaneous acts; rather, they were orchestrated to have the biggest impact. Taken from the place they had been

held since their arrest, both were beaten with the butt of a rifle in public. Liebknecht survived the beating and was finally murdered at the Tiergarten—shot in the back after being offered a false chance of escape. Luxemburg did not survive—she was too weakened and died from the beating. Shot in the head *post mortem*, her body was dumped in the Landwehr Canal.

Rosa Luxemburg's body was recovered from the water many months later, and on 13 June 1919 a memorial was held at which Carl Einstein is reported to have given an oration. The graveside oration given by Einstein is the subject of this collection of writings. There is no transcript or any other evidence of what Einstein said, how he said it, or what it addressed. No witness can testify. We cannot know. We may be sure only that it did happen. Of the many biographical notes that make up Einstein's inventory, few fail to mention it. The lack of detail is compelling, always only a few words: 'On June 13, he was one of a handful of speakers at Rosa Luxemburg's funeral.[2] 'He was a communist anarchist, participant in the 1918 Belgian and German revolutions (giving one of the graveside orations at Rosa Luxemburg's funeral)'.[3] 'He apparently spoke at Rosa Luxemburg's memorial'.[4]

The fact of the oration taking place in relation to the lack of any detail about it opens a fascinating gap and in consequence, the possibility to revisit, speculate on, and address in new ways these important events from a century ago and the ongoing influence of Carl Einstein and Rosa Luxemburg a hundred years after the event.

II

A wide range of people, including artists, writers, poets, art historians, and thinkers, have contributed their orations. These contributions represent many different styles, approaches, surfaces, and textures. There are songs and poems, letters and stories; some works are located in the political turbulence of 2019 while others address the characters and the historical contexts of 1919, often directly, sometimes obliquely.

The initial invitation was open, only sketching the outline of a sequence of events: a hundred years ago, two murders, a memorial, and a misrecognition. To this was added the scantest of details about the main characters, Carl Einstein, Rosa Luxemburg, Karl Liebknecht, and indeed, Albert Einstein. This was a loose 'brief', targeting a selected yet disparate group of potential contributors, whom I and my co-editor Sharon Kivland felt would engage in some aspect of the project in consideration of their work. This has allowed a space for the spontaneity of writing, and this book demonstrates a heterogeneity, the ethics which Einstein practiced and sought all his life. The richness and wide range of contributions is in keeping with this *Einsteinian* (my italics) approach, and I will introduce the texts briefly in the short essay that follows. The headings *Body*, *Grave*, and *Mourners* are not headings in the book, and they are not meant to be optics for reading the texts. I use them to introduce some of Einstein's ideas and to tell the story of Rosa Luxemburg's memorial. It is clear that all the contributions might sit happily under any of the headings, and it should be noted that finally the placing is only my subjective reading.

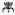

I would like to thank Sharon Kivland for listening to my idea and finding enough value in it to play a major part in its realisation. Beyond being my co-editor and publisher, the advice she has given me throughout has been invaluable. We both thank the contributors with all our heart for their generosity towards a project that offered nothing more than an invitation to respond to an idea— the response has been phenomenal and inspiring. We are grateful to Juliette Pépin for her work on the book, Kate Evans for her frontispiece illustration, David Mabb for the cover image, Sacha Kahir for the photograph under the epigraphs, and Katharina Ludwig for the photograph at the end of the book. The University of Huddersfield's School of Art, Design and Architecture kindly supported my work on this project, allowing me both time and financial support towards its realisation.

NOTES

1. Carl Einstein, *From Pilgrimage to Monarchy*, trans. by Charles W. Haxthausen, *October*, Summer 2003, Issue 105, Cambridge, MA: MIT Press, pp. 119–123.

2. Sebastian Zeidler, *Form as Revolt: Carl Einstein and the Ground of Modern Art*, Ithaca, NY: Cornell University Press, 2015, p. 3.

3. T. J. Clark, *Pity and Terror; Picasso's Path to Guernica*, Museo Nacional Centro de Arte Reina Sofía, 2017, p. 65.

4. David Quigley, *Carl Einstein: A Defence of the Real*, Schlebrugge: VBK Wien, 2006, p. 12.

BODY, GRAVE, MOURNERS

BODY

IT IS THE BODY OF Rosa Luxemburg and not Karl Liebknecht—
his body had been handed in to a morgue close to the Tiergarten
and registered as 'unknown' by the same militia men who had
shot him in the back on 15 January 1919. It is Rosa Luxemburg's
body because on 1 June 1919 it was her body that had been
retrieved from the Landwehr canal almost six months after her
brutal murder. In *Ein Stein in Mitten von zehn Gräbern* Katharina
Ludwig places the contested space of the identity of the 'body' of
Rosa Luxemburg at its centre, from its internment in June 1919
to its discovery in the basement of a hospital almost a century
later. In *Chapter Nineteen* Hannes Bajohr takes the final page of
Carl Einstein's celebrated expressionist novel *Bebuquin or the
Dilettantes of the Miracle*, through a substitution intervening in
the final moments of the story of a body in a state of agitation.
In *Widening Circles*, Uma Breakdown takes the image of water
when an object is plunged entirely into it; the gentle rippling
of these circles is part of an unbearable violence and waves of
grief spread across the surface of the water. At the centre of
Luminous Rosa by Alison J. Carr, Bede Robinson's 59275, and
Darryl Georgiou and Rebekah Tolley-Georgiou's *Who am I to
speak on behalf of the dead?* is the body of the female victim of a
political violence carried out by scared guardians of patriarchy
and capital; Rosa Luxemburg is recast as a lighthouse or a mirror
that shines across time and space illuminating a better future.
Sam Dolbear presents a body as the receiver of sensual data
beyond accepted limits, as the song of a wild bird apprehended
by a body within a body and the continuing influence of these
songs of liberation in *Zeezeebey*. The wings of a bird of freedom
and the angel of history bookend *Rosa! Soar, Rosa!*—for Derek
Horton, these wings wipe away oppression, opening the space
for freedom to think differently. In '*The Landwehrkanal Will Not*

Stop Geoffrey Wildanger connects Einstein's demand for the total revolution of art, present and past, and the revolutionary Marxism of Rosa Luxemburg to the continual flow of the Landwehrkanal. *Rosa My Dearest Rosa* is John Hyatt's Einsteinian expressionist eulogy, gathering the force of a battered body, a buttered tongue, an unavoidable face, and a committee of worms to present a renewed image of Luxemburg. Martina Mullaney rages over the body of Luxemburg in her own defence of the real against romanticising and nostalgia. In *A Rose for Rosa*, Zoë Skoulding is desperately seeking Luxemburg, constantly moving around the world, between places with the presence of her name, constantly disappointed at the absence of her body. Sonja Burbidge takes us on a journey from last gasps of breath through the frozen tectonics of rigor mortis to the decomposition of any body. Mark Leahy assembles speculations on eyewitness accounts of Einstein's oration at the grave of Luxemburg, none of which can report what he has said, but describe in detail his body language and answer the question, *What did he do with his pipe?*

GRAVE

A graveside oration requires at least a grave. The provenance of the body it holds might be in question but the reality of the grave is unshakable. Contemporary reports suggest that the memorial at which Einstein spoke was attended by hundreds. Since the 13 June 1919 many thousands have visited the graves of Rosa Luxemburg and Karl Liebknecht. *Graveside Oration* by Matthew Burbidge sets up a call and response between contrary positions to be sung at the graves of Luxemburg and her political partner Liebknecht. Three words are all that is needed for *The Transformation of the Real*, James Davies's powerful oration. Sean Ashton, Mark Curran, David Steans, and Betsy Porritt make the grave the centre of their orations; for Ashton and Steans the material muck of death, for Curran the beautiful recollection of a visit with his daughter to the grave of Luxemburg, while Porritt describes the discomfort and restlessness of the grave, cold and unwelcoming, all too individual. In *Canals 2018*, John

Z. Komurki maps a walk along the canal, the watery first grave of Luxemburg, revealing its character a century after it held her body. Tom Jenk's *38 Sentences for Rosa Luxemburg* is a map of ideas through questions and sentences. In *Forms grow rampant — a no god's eye view of Einstein's graveside oration for Rosa* Sacha Kahir delivers a multi-versional reimagining of Carl Einstein's oration that includes Einstein's own death, despatches from Berlin in 1919 and 2019, and Aberdeen in the 1990s. T.C. McCormack explores Einsteinian themes of memory in the story of a dead man and his objects. *Take a Moment for Yourself* by Martin Jackson flips around the best man's speech dilemma, offering sage advice to anyone unlucky enough to be writing a graveside oration. The impossibility of writing an oration haunts *Anti-Sentimental Love* by Ohad Ben Shimon, and in the process re-inscribes the mistake that tells us this was a graveside oration of *Albert* Einstein. Rowan Bailey's *Herr Einstein* is a letter from an inquisitive young art student studying sculpture in Leeds in 1919 to Carl Einstein, asking the author of *Negerplastik* for advice on making a ritual object. *What Dr Einstein?* is an excerpt from a longer text by Jeroen Van Dongen, exploring the cases of mistaken identity between Carl Einstein and Albert Einstein in 1919 and 1920. Kirsten Cooke transports Einstein's voice to the graveside on 13 June 2019, letting him speak through his own writings and a detour into the code-breaking Enigma machine. Christian A. Wollin's oration is delivered in Einstein's mother tongue, apart from the abrupt interruptions of noise interference; *Einsteinrosarauschen* brings forward Einstein's criticism of poetic form and arts effectiveness when faced with real existence.

MOURNERS

At any funeral, mourners are important. In 1919, hundreds of mourners attended the memorial for Rosa Luxemburg. Over the past hundred years, the importance of her thought and action has grown. At the centenary of her murder on 15 January 2019, thousands attended an event in Berlin. Are these mourners for Luxemburg? Or do they mourn the loss of a political possibility?

In *Carl Einstein Oration for Rosa Luxemburg*, Joshua Simon reminds us that the positions have shifted and warns against 'glamorising' these past events, asking instead that we acknowledge the presence of Rosa Luxemburg for now. Einstein's version of cubist thought and practice are crashed into Luxemburg's Marxism through Benjamin Seymour's *Darstellung, Lux: notes toward a supreme friction*, tracing its possible effects in the present with the *Gilet Jaunes* and the disruptive possibility of the courier (worker).

The past is revisited in detail in *A Eulogy for Rosa* by Ed Luker and *Farewell Blue Tiger* by Donal Fitzpatrick. Luker points to the counter revolution that betrayed Luxemburg and Liebknecht, and every worker then and since. Fitzpatrick finds the connections and the mutual influence of Luxemburg and Einstein, drawing out the points of contact in their political and emotional thought and practice. In *Some Thoughts on Anti-Fascism Now* Sophie Carapetian suggests how 'Fascism 2.0' should be confronted in 2019, in a letter describing her exhaustion after years of direct action, proposing how a defence against fascism might be technologically facilitated. In *In Rosa was our future, and now we are here* Louis-Georges Schwartz offers a resistant work of mourning, while *Is this the last time?* is Declan Clarke's bleak, unrelenting oration; both demand that we use the murder of Luxemburg to change our unequal society, or risk an inescapable tragedy. Fascism is a middle-class conformity driven by the storms 'economic and ecological crises' in *A Letter in the Storm* by Sean Bonney and Sacha Kahir.

The hours before the memorial sets the scene of Frank Wasser's *An Ordinary Mourning*, as Einstein prepares to fulfil his difficult task, and mirroring and breaking punctuate an emotional journey for Einstein. Sharon Kivland's tribute *Bouquet* arranges an excess of funeral flowers, an image of contemporary mass mourning that narrates the tragedy of Luxemburg's death. Mourning is demonstrated in orations in the form of personal letters: the anger, sadness, and hope of 'black queerness' of *A Love Letter to Andre Lancaster* by Nick Hadikwa Mwaluko; in *Dear Rosa*, Sarah Wood explores the immigrant, the lost wanderer

who was Einstein and the contemporary context of Brexit; and in *'And now, in all seriousness, a kiss, your R.'* Rona Lorimer recollects reading Luxemburg's letters during the occupation of an empty university building.

John Cunningham's sprawling, beautiful, and many-sided oration addresses absence in the historical record, filling it out in *Historical Blank*. In *Wake, Rosa* Benjamin Noys channels the spirit of Carl Einstein, a necromancy that speaks to the present as much as the past. In *An Address to the Living on the Eve of the First Centenary of the Spartakist Uprising* Pil & Galia Kollectiv make Einstein travel through time to November 2018 to deliver a paper on the legacy of Luxemburg and the economic crisis of 2008. *Love Among the Sailors/Don't Ask Me for Words* is Thomas Yeomans's oration, interweaving lyrics by Laurie Anderson and Eugenio Montale.

The afterword is provided by Spartakus. *Spartakusbriefe (Gelbe Westen) 16/11/–16/12/18* takes reports from online news media outlets focussed on the *Gilets Jaunes* protests of 2018/19. Through removing all references to place names and main players the piece draws a connection between these events and the Spartacist uprisings of 1918/19.

Through the multiple substitutions of Carl Einstein—a practice that Einstein pursued throughout his life—the themes of masquerade, mistaken identities, of persons substituted after the event, of orations, speeches, and texts rewritten, speculated upon, and redelivered that celebrate, map, and fictionalise a past life, are explored here. All capture something of the innovative and radical energy of Carl Einstein in 1919.

CRUD

WHO'S TO SAY HOW life will flash
in its hasty recapitulation,
who's to say the showreel won't jam
on a piece of the paltriest data,
memory of door handle, pine bench,
book we borrowed and never gave back,
crescent of nail dirt once dislodged
as we waited to see the doctor,
or unspool altogether behind the projectionist's door,
who's to say it won't happen thus
in the crux of unforeseen ends,
what are the odds of a fair deal
in the sweepstake of the unconscious,
what hope of ever formally thanking
the folk we slept with or quite enjoyed meeting,
or shall we reflect that all is valid
in the suddenness of a sudden death,
hair in the gate spoiling the whiteness
of the last thing we shall witness,
that some shall have nirvana, some snow,
while the others, the rest of us, have crud?

CHAPTER NINETEEN

First night—Rosa Luxemburg lay quietly among the white
pillows, stretched out, for some time staring at a hole
in the ceiling which didn't stir itself. For a brief moment
she thought she was swimming in slimy muck; then
she became feverish, and grabbed her head with her fingers,
hiding herself anxiously from the open window. She was not
capable of speech. After an hour she spoke with full control.

Second night—Rosa Luxemburg resisted going to sleep.
It might be dangerous, she thought she would become
too caught up in dreams. She speaks with great agitation
and senses that dark birds hover over her. The jaws lock.

Third night—Rosa Luxemburg goes to sleep peacefully.
Her hands jerked up a few times during her sleep, her face
gradually got cramped, the skin folded and wrinkled around
the whole skull. Her eyelids opened in fits and starts every
few seconds, she stretched her fingers and spread her toes,
then she contracted and trembled convulsively. Toward
morning she awoke, but was incapable of speaking and couldn't
eat alone any more. Just once she looked coolly and said

OUT.

15 January 1919

HERR EINSTEIN,

Allow me to introduce myself. I am a student studying
at Leeds School of Art, in Yorkshire, England. I have recently
encountered your book *Negerplastik* and I greatly enjoyed
reading it, especially your account of form and cubic space.
I have been trying to develop some of these ideas in my
drawings, but I would rather be carving in wood.
 I am writing to you with an idea. I would like to make
heads and masks in the round. I have in my mind a monument.
A monument for the many. A small and portable mask. Primal.
Magical. Transformative. Maybe made out of sycamore wood
or Elmwood. In your book you write that the mask is a 'fixated
ecstasy' and that the hybrid form of the human and the animal
are intertwined in a 'classical African equilibrium'. My mask
monument would carry these characteristics. It would be
reserved only for a funerary purpose. It, having of course,
a deep ritualistic function for seeing beyond material forces
of production.
 I fear that you may disregard my intentions. Having only
twenty-one years to my name, I know my psychic imaginary
may seem naïve or perhaps a little cuboid. But, in earnest,
I call upon your expertise as a scholar of African sculpture,
to see if my proposal has weight. I keep seeing in the pages
of my sketchbook an army of masks. All following the grain
of a wood groove upwards. Like trees.

I look forward to hearing from you.

 Yours sincerely,

 Henry Moore

A LETTER IN THE STORM

IN A LOVE LETTER ROSA LUXEMBURG states: 'It is the form of my writing that no longer satisfies me. In my soul a totally new, original form is ripening that ignores all rules and conventions. (...) I want to effect people like a clap of thunder, to inflame their minds...'

Jewish mystics and sorcerers sought the Tetragrammaton, or the true name of God. They believed that uttering this name would immanentise the eschaton; however, some said to say this name you would have to start at the beginning of time and finish as the last star is extinguished.

We barely sleep nowadays due to various poisons called things like 'amphetamines', 'news', 'brexit', 'populism', 'fear', 'withdrawal', and 'rent'. We talk for days almost non-stop. If you could form one giant compound noun from all we have said on these subjects keeping us awake, what would it say? Would it grant us something from the bureaucracy of angels and demons, operating like the jargon on German legal documents? Possibly giving us an *Anmeldung* (certificate of entrance) for the Ghost Dimension so we might be invisible to our enemies, for example.

We talk about the possibilities of a contemporary anti-fascist aesthetics. A kind of magical language that makes us indiscernible to all types of cops, both those in uniform and those that choose to police the borders of what is realistic, Social Workers, Social Democrats, therapists, and a long list of 'soft cops'.

Ernst Bloch described fascism as the 'Dionysus of mustiness', [1] while Pasolini said Hitler was the 'fruit' of the numerous 'Rimbauds of the provinces (...) the millions of *petit bourgeois* that surround us',[2] implying that Hitler was the poet of the deranged senses of the middle classes. At present we are witnessing an increasingly deranged conformity that binds us, with human extinction on its horizon. Pasolini saw a new form of fascism in the rise of commodities and the middle-class way of life.

Commodity culture and post war statehood had subsumed the (sub) proletariat replacing them with, according to Pasolini, 'their understudies...washed out, ferocious unhappy ghosts... Hitler's SS in fact'.[3]

Bloch's analysis of the German 1930s, *Heritage of Our Times*, reads alarmingly as a guidebook to our own era. We talk about what Bloch referred to as 'storm corners'—ideas useful to fascists but not in themselves fascist, and thus key battlegrounds for antifascism.

The social factory was closed down years ago—was turned into luxury apartments and then burned down in the riots of 2011. Fried by ecological and economic crises, terrified conformists are turning into actual fascists. Like everyone else, we admit, we're freaking out, made dizzy by the speed with which the social movements of half a decade ago have disappeared. Though even that fear is a storm corner.

We talked a lot about how to weaponise fear through a dialectics that could make it a miraculous weapon against the growing fascist creep. It is the anniversary of Rosa Luxemburg's murder at the hands of Fascists and Far Right Parties like the AFD are gaining traction even in the Berlin bubble where we reside. We haven't talked face to face for some time, but today I receive a letter entitled 'Letter in Turmoil'. 'It is no longer possible to have a balanced relationship with the world', it reads.

I read that somewhere in Ernst Bloch, throw the book at the wall, scream for a while, then run down six flights of stairs to the street below. This seems to happen just about every morning. I head to the canal and stand there staring at the swans, and pronounce certain words of shrivelled power. Theresa May, for example. Stephen Crabb. Of course, these words only have purchase in the Land of the Dead, but still I recite them, their syllables grinding together like the ghosts of medieval machinery, like a parade of headless skeletons or the wonder of a ghost train perfectly preserved in post-apocalyptic brine, the auditory bleach we bathe in every day. It's the Landwehrkanal and is famous. On 1 June 1919 they dragged Rosa Luxemburg's body from it. It had been there for six months. I think about that as I stare at

the swans. I also think about the well-known poem by Paul Celan that alludes to that incident, and about how he talks of the silence of the canal, or at least about how the canal has become silent, and I think about how wrong that is. Its inaudible radioactive signals never stop shrieking, an impossible music I've been unable to stop dancing to for days now, each of its notes the representation of an impossible world flickering somewhere just outside the borders of the known imaginary spectrum, those impossible borders, those ridiculous walls. We scratch ourselves to pieces on those walls. Or rather we write there. And what we write there would explode all known dictionaries were it not for the foul neoliberal glow of the so-called sun transforming all we have written into, once again, those aforementioned words of power. May. Crabb. Dirt and bones and gas. Yes every morning I sit there by the canal and when the panic has passed I murmur softly to the swans, and then I go home and dream that I have befriended them and they have flown high across the border and into the Land of the Dead, and there they have torn out the throats of all of our tormentors and they have passed a soothing balm among the souls of all those who continue to live but are trapped in that land, and obviously by soothing I mean usefully corrosive and deadly, and it is rare that I don't wake up in tears. I'm trying to stop that shit. I've been studying magic, utopia, and weaponry. I'll keep you up to date with my progress.

NOTES

1. Ernst Bloch, *Heritage of Our Times*, trans. by Neville Plaice & Stephen Plaice, Berkeley, CA: University of California Press, 1991, p. 56.

2. Pier Paolo Pasolini, *The Divine Memesis*, New York: Contra Mundum Press, 2014, p. 39.

3.Pier Paolo Pasolini, 'My *Accatonne* on TV After The Genocide', *Lutheran Letters'*, trans. by Stuart Hood, Manchester: Carcanet, 1991 [originally published as 'Il mio Accattone in TV dopo il genocidio', in *Corriere della Sera*, 8 October 1975].

WIDENING CIRCLES

WAR IS THE COARSE PARODY of revolution, and the murder
of Rosa Luxemburg was as thin and desperate an act
as the gape-mouthed wheedling of the spawn Moltke.

There are no lines of life today which do not run under water,
 or under the wet eyes of fascists and the organless police
who represent them.

This is at least true for today, but with padded feet we might tread
lightly as Mimi, passing close enough gut them all and be away.

The loss of Rosa is an impact which will be felt now and which
will form ripples. Some are sensitive to such vibrations and
we must bear the painful tremors they produce.

These ripples will call the fish to the surface, just as they cause
a thrum in soft whiskers.

For one the beating heart will be quickened, but the other will
find its lateral line ripped through, left gasping on the bank.

GRAVESIDE ORATION
—for seated solo singer and answering, moving chorus*
(Musical note: no music is unsuitable)

Yes. Yes. Yes. Yes.	No. No. No. No.
Yes, yes.	No, no.
Yes, yes, yes, yes.	No, no, no, no.
Yes, yes, yes.	No, no, no.

No, no, no.

Yes, yes, yes in the international.	No, not international.
Yes, yes, yes in the canal.	No, not the canal.
Yes; yes. Yes. Yes.	No. No. No. No.
Yes-yes-yes the blood.	No. No the blood.
Yes-yes the bullets.	No. No the bullet.
Yes-yes-yes idealism.	No. No; no idealism.

Yes, yes, yes.
No, no, no.

No, no.

Yes Lenin. Yes.

Yes. Yes red cold bloody murder.	No, Karl. No. No.
Yes. Yes cold red bloody murder.	No Rosa. No, no.

No we must. No we must not. No we must. No we must not.
No we must.

Now it is night. The tinsel is still there, but the crowd has gone. A little bird hops from Karl's grave to Rosa's and back again.

* (Singer sits on the left of the two graves; chorus ranged opposite on the right)

THESE ARE POSTMORTEM TIMES. When respiration ceases, the fight ends (for fighting is quite simply a laborious form of breathing).

Rigor mortis will soon befall an entire people... community will wither away... the call for unity will appeal only to human laziness... and leave behind nothing but a nation.

I'm indignant about the alleged peace of the dead.

Decomposition is a game of enzymes, composition one of the mind (the former often exploited by religion, the latter by government). Ideas pretend, and yet it takes the thought of someone who wants to say something ingenious through their actions to understand that one thing commits to all things.

Genossinnen und Genossen!

SOME THOUGHTS ON ANTI-FASCISM NOW

COMRADES,

I have decided to stop involving myself in organising in current anti-fascist constellations for the time being.

I strongly urge for a very regular co-ordination between existing groups and individuals committed to anti-fascist organising, and that this should take the form of a properly open public assembly. It should address the current political landscape we face with an honest appraisal of what has not worked tactically over these last years in dedicated anti-fascist organising, as evidenced by the strong and rapid global resurgence and reconsolidation of the far right in the interlinked street, state, and digital arenas.

This assembly must be broad and non-aligned to a single group or network. As things stand the constellations are moving in a very different trajectory. The micro tussles between existing networks such as the Anti-Fascist Network (AFN), London Anti-Fascists (LAF), and Plan C (PLANC) (PLANC in and of itself, as well as its various aligned, or front, groups) is not helpful in building the strong and expansive cultures of anti-fascism demanded by current contexts. The scramble for marking anti-fascist political territory is not conducive to effective anti-fascism. It reeks of a branding war fuelled by the prevalence and effects that social media has had on all political organising. We need to move beyond a position where we must lobby self-appointed leftist spokespeople for social media shares. Those who have amassed the largest follower counts by cynically adhering to the rotten social media rulebooks. We need to be able to call things out, show that their political values have traction and cut through social media personality cults. There needs to be a mind to what has eluded existing networks' tactics so far as to effectively stymie the far right. Things need to go beyond constant mobilising to

road block fascists. There is too much nostalgia for Cable Street and older forms of anti-fascism which misses the aim of FarRight2.0.

The assembly needs structures in place that prevent a single group from steering, branding, or caucusing: this is antithetical to building properly anti-authoritarian and expansive movements. Anti-authoritarian values should inform the assembly's structures and movement. The assembly would facilitate meeting common aims held by a wide range of groups. In this instance, we are united by our anti-fascist values, our commitment to anti-authoritarianism, *etc.*

There needs to be a reappraisal of what is considered militant anti-fascist work by proclaimed anti-fascists; for example organising by anti-racist groups, anti-police groups, state monitoring groups, community groups, *etc.*, so that a wide range of networks can get involved beyond social media endorsements. If a range of campaigns co-ordinate, offline, in a properly horizontal structure, these groups will not only turn up on the street when need be, but also bring fresh ideas to a discussion of tactics and the organised workload will be split.

There needs to be a serious consideration of authoritarianism, gender, race, and class politics in all anti-fascist groups: of how these forms of oppression inform the way people relate to each other in meetings as well more generally in the form and directions that 'horizontal' dedicated anti-fascism is taking. We have a serious resurgence of the far right and the current form of, and politics in, anti-fascist networks and groups is ineffective — this complex of issues is not unrelated! I have found the meetings textured by authoritarianism, classed, and sexist behaviours. The groups are pervaded by personality cultishness; there are informal classed hierarchies, obvious caucusing, paid activists —with zero transparency around that, general sub-cultural scenishness, and tons of sexist and racist crap. Just because a group or individual self-proclaims as anti-fascist doesn't mean it to be necessarily so. There must be a practical application of anti-fascist politics in the meetings and groups to avoid just revelling

drunkly in post-truth fuelled social media celebrity activism, and that becoming the binding standard for meetings. A well-structured assembly could start to address some of these issues, and build commitments to a politics of solidarity in its form.

Propaganda, as they call it, needs to be rethought beyond viral images: fly posters in community centres, especially those where fascism is creeping in. Targeting of certain areas, public meetings that draw 'non-activists' in and grow outwards. There needs to be a knockdown of the claims of the far right in image form and these circulated beyond left circles online. Images should not be regarded as secondary, illustrative, or merely stylistic afternotes. In the last eight years activism on the left has focussed too much time participating in online popularity competitions and meme wars; it hasn't worked well and we now have a large far right and a tepid, xenophobic social democratic project as our dominant mainstream political trajectories. Viral meme wars and Facebook likes are not the answer: last eight years of austerity, failed fightback paired with a rising far right resurgence has proven this.

If there was a horizontal co-ordinating assembly with a range of militant groups, then Momentum, larger unions, and Trotskyist groups could be invited to join without them being able to take control—this would open a space for larger mass mobilisations in which small militant groups could have a say, would be useful for direct action that falls outside of 'A to B' marches, and would get more people involved. An assembly could pull and keep Momentum as left as possible in a horizontal and formal way, provide a forum for mutual engagement and block parliamentary orientated projects from swallowing militant movement activity whole as we can see happening in the last years.

I think there should be a large free public cultural event; that this should be live streamed and collectively shared online. It should involve a large range of groups who should bring with them literature, stalls, speakers, and there should be an open mic. There needs to be a strong eye on the art world

and aesthetic production generally as there are now loads of fascistic art events and image production in the guise of the 'post-internet art' genre.

There needs to be much more open anti-fascist organising despite safety risks. Anti-fascism is insular and receding in its current forms. Fuck the police. Who cares if they are in our meetings? That becomes totally moot if there are large enough numbers—then they can really do fuck all. The same with fascist infiltration of groups. Security culture in anti-fascism prevents things opening to new people.

A properly co-ordinated social media strategy is needed with commitment to shared protocols and to the values that should inform them. We need to find a better way to navigate the social darwinist and financialised logics of social media's algorithms and not let our politics, organising, and relationships be subsumed any more than they already have been. The digital culture of mass conformism and veneration of popularity demanded by corporate social media platforms should be collectively and publicly challenged as it has proven to provide the most fertile ground for the far right to prosper.

I cannot be part of this directed work for the time being as I'm too exhausted by eight years of organising and too frustrated by the group dynamics. I am sick and tired of arguing with liberals in meetings. I hope these comments are useful for everyone. I will remain active in the existing groups of which I'm part and will continue turning out for demos.

In solidarity.

LUMINOUS ROSA

THAT ROSA LUXEMBURG INSTILLED FEAR necessitating her violent death is her triumph.

Conventional historical narratives may frame this moment in terms of political failure.

But, remember: the cards are always stacked against progressive, radical, visionary voices. Even more, from a woman with the temerity to speak. The cards are stacked in favour of the atavistic, the regressive, the lumpen, the crude, gross, and simplistic. The cards are stacked so that those who carry inside them an alternative are under threat physically as Rosa's brutal death and abandonment illustrate. The system, the status quo, is so weak it must crush its opponents so that the grinding, oppressive regimes of division and hatred can maintain a cruel domination, benefitting only the sadistic and greedy.

That her body was the site of violence, while she was striving for a new socialist utopia—a project of the mind, of imagining, visioning, debating, proselytising, and dreaming, says something about the efficacy of her thoughts.

Rosa never became sullied by political failure; while she was thinking, discussing, speaking, she was a beacon of light, a light that shall remain luminous. A light that will shine into the future, reminding those who see it that resistance cannot be extinguished by death. This moment, here and now, will be a site of topic in a hundred years from now.

Rosa was voice. Rosa was spirit. Rosa will outlive us all.

IS THIS THE LAST TIME?

ONE HUNDRED YEARS FROM NOW, will anyone remember this struggle? Will anyone remember this brutal death? Where will Germany be twenty years from now? Where will Europe be? Where will the struggle for equality amongst the co-inhabitants of these lands be? Will it even matter?

Perhaps we, and all that we leave behind, will have dissolved into a bed of scorched ash that will blow across the continent, devoid of nourishment to feed even the most adaptable plant. Perhaps the death of this extraordinary woman, our cynosure, who guides us still yet through the pitch dark, will be the last. And if not, how many more?

Can it get much worse than it is now? Probably. Almost certainly. But what of it? Let not this death, nor the next, be the one that opens the gates. Nor the next hundred, nor the next hundred thousand. As long as we have our collective voice and will, let us recall the example of our fallen comrade. If we cannot win, and we can no longer fight, we can always say, loudly, what is unjust, as she in turn learned from her forebears. And by these words, we can defend and uphold the dignity of those who have fallen before us, and give strength to those who shall fall in our wake.

From dust came the universe, and from the dust of this grave can come a just and equal society. Without that, we have all failed, failed utterly, a terrible tragedy is born.

LET ME TELL YOU A STORY...

CARL EINSTEIN'S PRESENCE HAUNTS US on this day, 13 June 2019, as a voice from the past projected into the future takes this opportunity—at Rosa Luxemburg's graveside—to continue politicising his theory of 'decomposing' and recomposing vision through form.[1] Einstein, in fact, has had to decompose the many iterations of himself and recompose his body—a Frankeinstein, as it were—to take his place memorial-side.

Einstein has watched the twentieth century and early twenty-first century from the side-lines and concurs with Giorgio Agamben's statement on the nature of contemporaneity, as this endows him with a unique perspective:

> Contemporariness is, then, a singular relationship with one's own time, which adheres to it and at the same time, keeps a distance from it. More precisely, it is *that relationship with time that adheres to it through a disjunction and an anachronism.* Those who coincide too well with the epoch, those who are perfectly tied to it in every respect are not contemporaries, precisely because they do not manage to see it, they are not able to firmly hold their gaze on it.[2]

From his spectral and anachronistic standpoint, which has been regenerated into a tangible entity for this centenary oration, Einstein now intends to advise the congregated listeners on how to continue hacking forms. Alongside Einstein's own theory of decomposition, he will also refer to the operations of two other hackers: Gordon Welchman, who worked during WW2 (the war that also saw the tragic end of Einstein's own life) to decode the Enigma machine, and Keller Easterling, who interrogates the disposition of contemporary infrastructure space. These figures, similarly to Einstein, decode in order to recode the forms that make up their respective political environments.

For all intents and purposes—and consistent with the medium of oration—Einstein wants to tell you a story, a device that Easterling defines as being an active form that can have

spatial intent: 'A story as an active form, however immaterial and non-spatial, can inflect disposition in infrastructure space and can be deployed with spatial intent'.[3] Einstein will now tell you a story with spatial intent. Einstein clears his throat and begins.

In 2019, we are still at war and the war is still the battleground of forms that configure how we see and interpret our political and social landscapes.

PAUSE—slight cough.

I have long since critiqued the notion of 'optical naturalism', which builds a form out of the subject's memory.[4] For if a form requires the subject to fulfil it then it will always preserve the existing subject's experience of forms rather than challenging their expectations. This type of form making encourages the viewing subject to believe that they are in control of the world and naturalises their view point. The difference between a form that acts conservatively, by naturalising our view point, and a form that can revolutionise our perspective is articulated by Easterling as being the distinction between form as object and form as action:

The distinction between form as object and form as action is something like philosopher Gilbert Ryle's distinction between 'knowing that' and 'knowing how'. With characteristic clarity and simplicity, Ryle once explained the difference between the two by using the example of the clown. The clown does not possess the correct answer to the question, 'What is funny?' The clown's antics are not a single reasoned executive order. His knowledge and experience unfold in relation to the situation, from encounter to encounter, circumstance to circumstance... What is funny involves a set of choices contingent on the audience's reactions, and the clown's performance relies on a 'knowing how' rather than 'knowing that'. For Ryle, the clown's skill represents 'disposition, or a complex of dispositions'. 'Knowing how' is, for Ryle disposititional.[5]

Einstein shuffles his feet slightly and regains his stature while using this opportunity to assess his audience.

This notion of 'knowing how' gives us the means with which to analyse the dispositions of powerful organisations and systems, which are articulated in the forms that make up our political and social infrastructures, as well as the tools with which to rewire them. Gordon Welchman, who was responsible for the infrastructure of the Hut 6 operations at Bletchley Park (an organisation that was deployed to crack the codes produced by the Enigma machine) also highlights the benefits of scrutinising the disposition of your enemy.[6] It was through identifying the behavioural patterns, which in a poker game would be referred to as the other players' 'tells', of the Enigma machine operators (tells which Welchman refers to as the 'Herivel Tip' and the 'Sillies') that enabled Hut 6 to undertake much of its early decoding:

The two astonishingly bad habits that now enabled us to go on breaking Enigma even without females were dubbed the 'Herival Tip' and the 'Sillies'.[7] The first often enabled us to guess the ring setting of each wheel to within two or three letters; the second often allowed us to guess text settings. Both had to do with the lazy habits of the German operators.[8]

It was through interrogating the dispositions of the German operators and the 'knowing how' of the Enigma system that enabled the Hut 6 team to decipher so many of the German messages and then to use them to the advantage of the Allied military. The dispositions of the operators, enabled Welchman's team to understand how the design of the Enigma machine is used and which lazy habits could give away the code. It also enabled them to hack the codes produced by the Enigma machine and then encode or operate the system themselves.

Einstein coughs again, then sips some water that has been offered by a member present at the gathering.

I would like to draw your attention to my 1915 essay, '*Negerplastik*' in which I discussed the power of active forms in African sculptures. I would like to suggest now, that the 'knowing how' of cubic form enabled certain tribes to encode a spatial experience that I proposed could shatter the western tendency to 'know that'. Cubic mass produces active forms and counters the two conservative models present in the western tradition of producing forms; 'frontality' (concentrating all power in the image toward one aspect) and 'three-dimensionality' (projecting the viewer's experience of movement into the object). Both are conservative forms because they require a restrictive and repeatable master plan, as opposed to deploying an operation that adapts over time. To refer back to one of my statements in the essay:

This is how one should understand the so-called twisted joints or limbs of Negro sculptures: this coiled bending represents in a visible concentrated way the cubic character of two otherwise abruptly contrasting directional movements; recessed parts that could otherwise merely be intimated become active and functional in a focused, unified expression.[9]

In this sense, cubic mass operates to encode the sculpture with active forms so that the object can turn what Easterling describes as a 'switch' in the viewer's perceptual field and, therefore, hack the field of contemporary image consumption.[10]

I conclude my story with an entreaty to the audience to keep hacking the contemporary neo-liberal landscape through active forms, as Easterling states: 'Active form is not a modernist proposition; it does not replace or succeed object form but rather augments it with additional powers and artistic pleasures'.[11]

NOTES

1. Georges Didi-Huberman (1996), 'Picture=Rupture': Visual Experience, Form and Symptom according to Carl Einstein', trans. by C. F. B. Miller, *Papers of Surrealism: The Use Value of Documents*, 7, (2007), 1–25.

2. Giorgio Agamben (2006), *What Is An Apparatus? And Other Essays*, trans. by David Kishik and Stefan Pedatella, Stanford, CA: Stanford University Press, 2009, p. 41.

3. Keller Easterling, *Extrastatecraft: The Power of Infrastructure Space*, London: Verso, 2016, p. 90.

4. Sebastian Zeidler, 'Totality Against a Subject: Carl Einstein's *Negerplastik*', *October*, 107 (2004), 15–46 (p. 29).

5. Easterling, *Extrastatecraft*, pp. 81–2.

6. Hut 6 is also where Alan Turing worked to decode the Enigma machine during WW2.

7. 'Females' are used by Welchman to describe the same letter pairings, which were provided by the encoded 'indicator' (German operators would repeat the three-letter code twice, thus producing three-letter pairings) that came with the German messages early on in the war (this changed on May 10 1940), so that the receiving operator could identify the 'indicator setting' that would tell them how to organise the Enigma machine in the correct text setting, so that they could decode the message. Hut 6 used these 'females' or pairings to hack and decipher the text setting until this came to an abrupt end in 1940 on the day of the German invasion of France.

8. Gordon Welchman, *The Hut 6 Story: Breaking the Enigma Codes*, London; Allen Lane/Penguin Books, 1982, p. 98.

9. Carl Einstein, 'Negro Sculpture', *October*, 107 (2004), ed. by Sebastian Zeidler, Cambridge, MA: MIT Press, 122–38, p. 132.

10. A 'switch/remote' is used by Easterling to describe the way the flow of activities are modulated within a system. In infrastructure space, Easterling states that switches/remotes act as multipliers that repeat throughout the system to modulate the behaviours of its users.

11. Easterling, *Extrastatecraft*, p. 84.

HISTORICAL BLANK
THE LOST EULOGY OF CARL EINSTEIN

'If there is future abundance it comes from the nothingness,
the unreal. That is the only guarantee for the future.'
Carl Einstein [1]

WORDS ARE UTTERED, THE CROWD listens, heads craned forward
respectfully. A man in a crumpled black suit, wide forehead
obscured by his hat, thin lips downturned. The deep lines on
his face recede downward into his collar. Carl Einstein speaks
at the soon to be filled grave of Rosa Luxemburg but what
Einstein said is one of those historical instances that are blanks
in the written record. A funeral eulogy, a speaking well of
the dead, overcast by the noise of street fighting, flight, prison.
Words uttered out of the failure of the Spartacist revolt. That
particular rupture that aimed at the cessation of the temporality
of profit driven utility, the regressive progress that establishes
past, present and future as a continuum only ever ending in
the now of capitalism.

One perspective upon this, validated by the words uttered
marking a defeat and being spoken by one of the defeated,
would be that the funeral eulogy is an event compressed
into the ledger sheets of seemingly frozen, empty time to
be crumpled up and thrown away. All that exists of it in the
historical record is the geometric finality of the names of
some of those present, the date, the reason for the occasion.
Lines and trajectories of the living and the dead but no fulsome
words issue into the future.

Progress as the accumulation of profit, commodities,
factories and department stores, labouring death as the
reproduction of life, the usual conflictual, brutal continuity
produces such silences.

The blank space thus constituted might fold further into
historical silence, a temporal site especially reserved for those

utterances that scrape counter to the chain of causality that ends in capitalism as the outcome of universal history. If subsumed such a historical blank suggests no form capable of expressing the moment of utterance. The moment might fold beyond speculation into a spreadsheet of carefully calibrated historical time. This smooth continuum of history, the dominant temporal modality, would ensure that possible tears or holes, the moments of possible rupture, are calculated and marked as closed, dead. Nothing was said here. Move along.

However, there is a tension running through an absent object such as Einstein's funeral eulogy. As much as it is erased it also hangs silently as a moment potently ungrounded. An unrecorded utterance might paradoxically be an unfolding discontinuity, a nothingness that may give rise to speculative forms that are moulded by the blank moment they issue from. Forms that are emblematic of the disruptive uncertainty of time as it occurs rather than fully constrained by a retroactively imposed causality, the structure of the continuum of empty time.

A blank space might also, then, be marked as a possible rupture. If so, the forms of writing it might invoke proliferate into various theoretical fictions. The blank space, the nothing, of Einstein's speech might unfold into a negatively accumulated abundance, always holding groundless absence close. It might open into attempts to restore contingency to what is deadened in the continuum of empty time, past, present, and future. The different forms of writing would need to maintain a mobile, disintegrative momentum in keeping with the groundless absence that constitutes their ground, one undercutting the other.

A speculative puncturing of the continuum that must always retain the silence of erasure at its centre, or else it would be a lie.

EULOGIES FOR THE EULOGIST

'This literature has grown up around a veritable pawnbroker's shop.'
Carl Einstein [2]

Different personae or masks not so much of this writer as of *literature* construe Einstein's lost eulogy according to their affective predilections, literary conventions, and momentary caprice. The first is the Dramatist, convinced of the disavowal of language and discourse in favour of gesture and silence. The second is the Poet, lost in the contemplation of the eulogy dissolved into the sepulchral sky of nature. The third is the philosophical Pessimist, discovering in Einstein's eulogy the confirmation that all that happens inevitably slides to disappointment, a resounding nothingness. All register the blank space left in historical time even if as cultural treasure to be pawned. Each is followed by a short commentary that disavows the attempt at exposition.

SPECULATIVE SILENCE

The Dramatist: Perhaps, rather than speaking Einstein simply cannot find the words. He is exhausted by his recent experiences of street fighting, flight, prison. His mouth opens and there is a silence non-echoing mouthed from the vocal folding of the larynx, the micro movements of tongue and mouth, the rush of air from the lungs. The sublimation of defeat in the 1919 Spartacist revolt resolves into an involuntary cessation of language, a tying of the tongue, the knotting of it into a whorl of tactile but silent flesh. For an interminable amount of time Einstein's face works to issue words, grimaces, contorts in a slapstick nightmare. Einstein stands in shock, turns and leaves. Luxemburg's corpse continues to moulder in the coffin. The crowd at the funeral shuffles uneasily. There is nothing to record in this silent melodrama. The curtain closes on a scene frozen. According to the directions of the play the audience exits without applauding.

Commentary: Of course, none of this happened, and Einstein undoubtedly said something in his eulogy to Luxemburg. His

undoubted and passionate skills in writing and insurrection make this certain. Still, his words have with equal certainty disappeared, eloquent in their very erasure.

LYRICAL ERASURE

The Poet: Perhaps, his words simply dissolve into the bright June sky of 1919. This is the form the liquidation of memory might take for certain poets. I would say the sky knows nothing of human language, only the signs of clouds, light, and rain clumsily apprehended from the ground. The indifferent light of that particular summer day, the slow turning of the planet, ensure that whatever Einstein said has dissipated, is unregistered by those present. An inhuman, if gentle, planetary finitude ensures Einstein's words are forgotten.

Commentary: This in no way apprehends the blank space of the eulogy. The words were not immersed in the summer pastoral of the cemetery sky. Einstein's carefully phrased oration did not disappear into the prosaic mysticism of natural surfaces. Such an elegy has none of the violence that transfigured and infused Germany and Berlin in 1919.

The disappearance of Einstein's eulogy is a much less lyrical erasure, imbricated with the unnatural surfaces of civil war: chaotic geometries of violence, city streets, bodies.

SPLENETIC GRAVE

The Pessimist: Perhaps, Einstein's words are uttered and then swallowed by the open grave before him. His syntax becomes the auditory equivalent of fresh earth rattling on the sealed wood of Luxemburg's coffin. In this, the eulogy speaks well only of the hollow, useless shapes ultimately assumed not only by resistance but ultimately by the ontological uselessness of life in total. To speak is to grieve but speech inherited by the grave is mourning incarnate. The lost eulogy is sustenance for the grave.

Commentary: This has too cosy a relation to the grave as a silent receptacle for grief. Graves, especially when cut into

the earth through the convolutions of political violence, are splenetic, disquieted. The words are more likely to languish after being spoken and cannot discharge their task of mourning the dead Luxemburg, revolve with a furious discontent, caught in a syntax of repetitive, melancholic revolt.

The act of mourning is curtailed by the continued fractious blossoming of Weimar capitalism. Einstein's funeral eulogy is collectively absorbed by the tired, defiant crowd of mourners, an undefeated despair. This readiness to not let the dead lie quietly and struggle anew alongside them ensures that recent history is ripped open anew.

The trauma of violently imposed order does not allow corpses to be interred with ease and comfort, delicately and constructively mourned, even as an element in a comprehensive pessimism.

SPECTRAL DECLARATION

'"Order reigns in Berlin!" You stupid lackeys! Your "order is built on sand. The revolution will "raise itself up again clashing," and to your horror it will proclaim to the sound of trumpets: *I was, I am, I shall be.*'
Rosa Luxemburg [3
]

A banner, rough memorial reproduction screen print of photograph	Luxemburg grainy
Luxemburg's eyes caught gazing directly at an angle	smudged profile
present at her own funeral inanimately	eyes gaze
crowd of living retains affinity of the dead	with collectivity
rough memorial reproduction	banner,
Luxemburg's last written words 'I was, I am, I shall be!' declaration	spectral
new body of syntax	devoid of canal
stench and decay	
spectral declaration	circles around

the burial site
hovers over the mass of mourners adorned in funeral
best
tattered work clothes
awful clarity unity of living and dead counted in all
their disquietude
disinterred from failed revolt spectre in the
form of syntax
points with newly dead finger possibilities
impossible redemption of past, present,
future
recently dragged from the slurry
of the Berlin canal
somatic clichés of death (rot, decay)
by a beating by being shot
murdered
angry, disillusioned *Freikorps* militia see them laugh
coarsened industrial warfare future
catastrophes
the crowd defiant in
collective mourning,
living bodies tensed exhausted
struggle
alive to a spectral syntax from the dead to
the living
words at the funeral embody defiant
ghosts
words fade away time unrecorded

THE RED CRAB: A FICTION

'The time seems to have come to identify the crisis, not to offer
support to things as they gain stability, given that we are [...]
surrounded by people who wish to live without being dead.'

Carl Einstein [4]

The recent discovery of a cache of papers belonging to one Otto Kreb
has led to fresh hope that the contents of Einstein's funeral eulogy
to Rosa Luxemburg might be discovered. It is worth outlining, very
briefly, the life of Otto Kreb since he is a figure relatively obscure
to both literature and history. Born in 1890 Kreb was successively,
at times simultaneously, an anarchist, minor expressionist poet,
soldier, revolutionary polemicist, and Spartacist activist. While
this might seem an exhaustive and exhausting life itinerary it is but
an echo of the parallel lives of many writers, artists of the time.
Figures such as Carl Einstein but also Victor Serge, B. Traven, and
innumerable others were similarly subject to different strains of the
self, exilic personae conscripted to political crisis.

Much of what is known of Kreb has been gleaned from a few
extant published texts, the anecdotes of friends, comrades, lovers,
the occasional mention by enemies on both the Left and the Right.
The latter nicknamed Kreb the 'red crab' in their press, playing
on his name (Kreb/*krabbe*). Kreb delighted in this moniker,
often writing as 'the red crab' in preference to his given name.
The attempted insult even infiltrated his poetry or as he wrote in
Pincer Movement: 'Always moving sideways, the rubble and trash of
this world, is my shell...'. *Pincer Movement* probably remains Kreb's
most remembered collection of writing though also of note is his
Dadaist polemic *The Guillotine Gateau*. This is a phantasmagoria
of the Berlin bourgeoisie being butchered and eaten by the very
food they desire, hallucinatory in its xenophagic violence. Georg
Grosz was said to be greatly impressed by its depiction of the
bloody revenge of the soon to be eaten foodstuffs on a gallery of
overweight businessmen, military, and various politicians.

Kreb also wrote for *Die Rote Fahne* (The Red Flag) and *Die
Aktion* (The Action) so may have even known Luxemburg, one
of the editors of the former, and Einstein, who wrote for the

latter. Kreb was also a participant in the Spartacist revolt, seen on the street with rifle and Mauser revolver. Through the 1920s his literary endeavours seem to have been put to one side in favour of reporting on strikes, uprisings, economic crises as well as his periodic visits to France, Spain, and the Soviet Union. With the ascension of the Nazi party to power in 1933, he fled Germany for Denmark, then France, before enlisting on the Republican side in the Spanish civil war. Kreb died in an attempt to cross back into France in 1939, gunned down by a Falangist militia. The Red Crab finally had nowhere to go.

The papers of Otto Kreb were discovered ignominiously buried under a stash of dusty, tattered 1920's fashion magazines in a junk shop. They were covered by an avalanche of almost forgotten Weimar novelties and hints and tips for the New Women and Men of German capitalism, a jarring mix of sharp costumes, jazz, and cabaret, Aryan nudist colonies, Bauhaus design, art deco cigarette advertisements, images of mountains and department stores. It seems fitting that some of the few extant reminders of Kreb's existence should lie hidden under the accumulative detritus of the history of Weimar capitalism.

The papers are a combination of type-written documents, seemingly for publication, and handwritten notes in Kreb's infamously tiny script. Kreb's miniscule annotations are evenly balanced between the neatness required of a militant functionary and the scrawling intensity of the poetic revolutionary, a tension not only of graphology if what is known of Kreb's life is correct. This script is notoriously difficult to decipher and it remains open to conjecture if this miniaturisation is simply a reflection of Kreb's character, his precarious mental health, or of his proclivity towards secretive political activity. It is not difficult to imagine Kreb crouching his gaunt, tall frame over any one of the provisional locations the pendulum of poverty, politics, and war might have given him as a space in which to write. A salvaged desk, varnish flaking, in a boarding room; the rough confines of a bunk bed in a regimental barrack before lights out; a café table overflowing with coffee cups and schnapps glasses; the paranoia infused basement of a soon to be disappeared or outlawed communist or anarchist

journal or news sheet. Much of what might seem dangerously romantic about Kreb's life is only the secret route to more profound levels of the boring stratagems required to survive.

Unfortunately, the account of Carl Einstein's funeral eulogy remains hidden by the anarchic discipline of Kreb's neat imprecision. While the title, 'An Accumulated Disintegration: Einstein on Luxemburg', can be easily read, the rest becomes a tangle. It resembles a lost hieroglyphic grammar, the remains of a mysterious civilisation, especially when viewed close up. This is the conundrum of Kreb's script. From a distance his letters appear well formed and carefully inscribed; it is only when examined closely that they lose sense and focus. Readers and researchers of Kreb continue to try to decipher this script and it may only be hoped that one day the blank historical space of Einstein's eulogy will be filled by Kreb's miniscule documentation. Several have been plunged into despair by the attempt to discover in the broken reflection of Kreb's script the rudiments of what Einstein said but they are determined, they say, to continue trying.

ACCUMULATED DISPERSION

'I have been trained to find negation everywhere.'
Carl Einstein [5]

Words are uttered, the crowd listens, heads craned forward respectfully. A man in a crumpled black suit, wide forehead obscured by his hat, thin lips downturned. Carl Einstein speaks at the soon to be filled grave of Rosa Luxemburg. Einstein most certainly did not say anything like this:

The purposeful senselessness of the ticking clock of cyclical progress has brought us here today at the grave of Rosa Luxemburg. We ought to twist the hands of the time-piece into a different shape or attempt to break this cluttered blankness of time that rushes towards the expression of newly built ruins, further crises of ever moving stasis. Instead we stand before the grimace of smiling catastrophe, pristine as it is in this mess of upturned earth that threatens to hail down upon us all. We discover ourselves standing here upon this groundless ground with the elaborate simplicity,

that is the struggling repose of the defeated. Look at yourselves and look at me standing with you, a crowd of particularities, that is the mob of the singular. All of us have proper names replete with anonymity, those names to use in the nowhere of the places we work, live by dying in, as utterly essential and dispensable to the factory, hospital, university, prison, barracks, railway and port. We are situated between animate and inanimate, the animation of the inert, both dead and alive in the ways that we take on the form of a corpse alive through what can be bought and sold, traded and stolen, including ourselves. The accumulated dispersion of a mass of well-defined inchoate personae is all we are unless there is the ungrounding, revolutionary gesture that grounds us in the slipping, always moving earth. Rosa Luxemburg sought to bravely instantiate such a new stateless state of the world by acting as one of this collectivity of workers and unemployed, names both singular and anonymous. Her insight that, and I quote her, 'revolutions do not allow anyone to play the schoolmaster with them',[6] that spontaneity that is beyond causal miscalculations is the ungovernable, always receding foundation of the destruction of political certainty is what we ought to attend to in this moment. That is, the moment we retain even as it slips away, the particular moment that always returns, the novelty of negation.

And then Einstein fell silent.

NOTES

1. Carl Einstein (1909), *Bebuquin*, trans. by Patrick Healy, Dublin: Trashface Books, 2011, Chapter 6, Kindle Ed.

2. Carl Einstein (1929), 'Andre Masson: An Ethnological Study', trans. by Andre Diamanche, *Undercover Surrealism*, ed. by Dawn Ades, Simon Baker, Cambridge, MA: Gallery Publishing/ MIT Press, 2006, p. 245.

3. Rosa Luxemburg (1919), 'Order Reigns in Berlin', trans. by Ashley Passmore, *The Rosa Luxemburg Reader*, ed. by Peter Hudis, Kevin B. Anderson, New York: Monthly Review Press, p. 378.

4. Einstein (1929), p. 245.

5. Einstein (1909), Chapter 5, Kindle Edition.

6. Rosa Luxemburg, quoted in Sebastian Zeidler, *Form as Revolt*, Ithaca, NY: Cornell University Press, p. 16.

STYCZEŃ / JANUAR / JANUARY

At my desk, you gaze out of the photograph.
Implicating. I often wonder is that evening light in your eyes.
Vivid. A half-smile. Even now.
A reminder. Revolution. Always.
Struggle. Social justice.
A Constant.

I could not be here the first time.
The flowers, vivid red,
Coated in white January frost.
So many. So many have come.
To remember. And dwell.

That photograph. Your shadow.
I notice the brickwork, just over your shoulder.
I have tried to find out where it was made.
Was it here in Berlin?
Perhaps from the time of the Kaiser.
Before the war.
The one, they said, to end all wars.
They said. You knew and determined.
The audacity of your conviction
Met with brutal and devastating retaliation.

I could not be here the first time.
The brickwork at the cemetery appears the same—'*backstein*'.
Frozen sunlight throws our shadows.
Mine, and those of my daughter.
She runs among the circle of headstones.
Reading the names. Out loud.
And yours.

An elderly couple appear. Near us.
Shuffle. Crouched slightly.

I listen. Not meaning to overhear.
They are speaking about
And to you too.

I could not be here the first time.
Now, with my eight-year old daughter.
'Do I really have to go?'
I wanted to introduce you.
'*Alles ist rot*', she says.

I go to make a photograph.
She runs in front. Jumps. Jumps twice.
In view. The viewfinder.
Arms outstretched. Fists high. In the air.
Smiling. My daughter.

You have brought us here, Rosa.

Berlin, January 2019

THE TRANSFORMATION OF THE REAL

Rain Now Friends

ZEEZEEBEY*

THE EDITOR WRITES: 'In German folk tradition, children born on Sunday, particularly under a new moon, are likely to possess special powers, such as the ability to see spirits, speak with the dead, or have their wishes fulfilled. The term *Sonntagskind* is also used figuratively to refer to someone who is "born under a lucky star", who has an easy time with things that are difficult for others, or for whom each day is imbued with the spirit of Sunday.'

Draw the sound of bird song: outside the cell, a wagtail. When the bird song ceases, the sonogram can be read, can be sung. You were a *Sonntagskind*, born on the Sunday thirteen days before the start of the revolutionary government of the Paris Commune. From inside, you could hear the birds sing, those songs of freedom, detachment, and alarm; those songs that today cannot be heard, but they sing on: for Sunday's child, for the abolition of the very days of the week, for the liberation of prose and song and script and language and nature.

The writer writes: 'The messianic world is the world of universal and integral actuality. Only in the messianic realm does a universal history exist. Not as written history, but as festively enacted history. This festival is purified of all celebration. There are no festive songs. Its language is liberated prose—prose which has burst the fetters of script [*Schrift*] and is understood by all people (as the language of birds is understood by Sunday's children). The idea of prose coincides with the messianic idea of universal history (the types of artistic prose as the spectrum of universal historical types).'

* Based on a letter from Rosa Luxemburg to Sophie Liebknecht, 23 May, 1917.

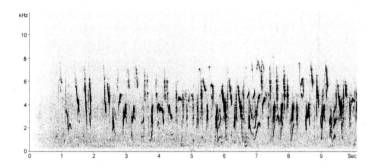

Sonogram of a White Wagtail (*Motacilla alba*)
Parque Nacional de Monfragüe, Extremadura, Spain
(39° 49' 54.23" N 06° 01' 41.95" W) 13 June 2013
Song from shoreline of Río Tajo
[from www.fssbirding.org.uk/whitewagtailsonogram.htm]

FAREWELL BLUE TIGER

Farewell blue tiger.
Your incandescent voice, always at the service of the poor and powerless, no more disturbs the air, your voice falls silent at the hands of oppression but you the friend I cherished cannot be silenced as your body was silenced. As sound travels with greater efficiency in water than air so the sound of your thought will reverberate forever in the depths of political thinkers and social activists eternally.

Farewell blue tiger.
The curse falls to this generation to know the future. You have ceased consciousness and left the fray but we who remain live the nightmare you predicted. Europe's sickness spreads across the eclipse of the continent. This is a darkness that cannot be known, it comes directly and yet cannot be detected. Only in its disturbances can it be perceived and through its terrible effects.

Farewell blue tiger.
The price the social democrats will pay for their weak interaction with this monstrous intrusion will be utter annihilation. They believe in a past, a return to a mythical order of capitalism with a benign face, in a desire to reclaim a nostalgic empire. How you would laugh to hear them, you taught me that all memory is a recreation and none more so than the poisonous fictional nostalgia for a time that never was. You would laugh out loud knowing as you did that contrary to their insane fantasies we are witness to the terrible disruptive birth of something evil and above all, something new.

Farewell blue tiger.
Your voice is always there where it is not. To paraphrase your sweet conversation, freedom is only freedom if it embraces those who disagree with consensus and it reserves its love only for such ones who think differently. Such an equitable model of democracy is

beyond the social democrats they prefer endless postponement, the gift that never arrives despite their showcasing of baubles and belief in an unforced future.

Farewell blue tiger.
It was inevitable you would be betrayed by your own side of politics. Your commitment to permanent revolution, your understanding that freedom is not a special privilege doled out to an elite of ideological puritans determined your fate as an embarrassing torch of truth displacing their lies. In your mind and thought freedom is a public right, an event that arises in the situation of politics and leads to the destruction of the repressive order of stasis in the existing situation.

Farewell blue tiger.
These parasites of the socialist endeavour have celebrated their victory of your extermination by blaming others but we here will remember their names, Ebert, Pabst, Runge, Vogel, and Souchon. We shall remember them when even the coming darkness has gone and all the precious cargo of their rancid nostalgia has crumbled to dust. The pushback will inevitably come, a response is always demanded, the real cannot be mastered permanently; it can only be subverted temporarily, and eventually the real will return to enact its terrible vengeance. The response will come and it will be both equal and not the same as the crime. It will be terrible in its thoroughness and in its lack of infernal restraint. It will not cease until all such intrusion is annihilated. The smell of your murderer's bodies will be the only perception these furies will have of this existence and their retribution will be as merciless as it will be unassailable.

Farewell blue tiger.
How are we to dwell in the blue jungle of Kirchner's outline and the red tumult of Grosz and the realist imaginary without your sure vision and vigilant pursuit of life's attestation. You have left us here in this growing darkness where socialists no longer dream of being internationalists but settle for squalid nationalism, where the detestation of the other in all its racism and greed is worshipped in a cult of senseless selfishness.

Farewell blue tiger.
Here before this open grave I understand the permanence of your absence. The loss of a friend in a shrinking emotional desert of support. How can I continue to reason without you. How can I speak? How can the people race towards the precipice, the smiling dragons, the darkened doorways filled with magnetic sharks, and not see?
All that they read is corrupted
All that they hear is lies
All that they need is promised
All that they blame is others
All that they destroy is each other
And not see.

Farewell blue tiger.
The primal air passes between us for one last occasion. We can only refuse and stand with a silent sentinel of sculpture against the ignorance that would enslave us. To make again the meaning of your sublime friendship. To climb into the stars of freedom. This is the joy of your remembrance, the marvel of your courage, the fierceness of your conviction. There are no illusions, we cannot take up that toxic burden and mount the unicorn. I must be vigilant in your memory even though the path may take me to the same place from where you now sing to me of my liberation. I dare to follow.

Farewell blue tiger.
I stand here before your absence. I tear at my clothes with modesty. I shall place a stone so that you may live on in our heart's memory with permanence.

WHO AM I TO SPEAK ON BEHALF OF THE DEAD?

DEAR ROSA. SOME CLOSING WORDS. There is little time to mourn.

The winds of fascist history have taken you. Bloodied and beaten, your last breath is smashed away from its bodily mooring. Our rebel of the revolution, your life seized in private execution, demanded by the dictatorship of the few.

Yours was the glittering mind to the open revolt of a generation, the roar of thunderous conviction, igniting Spartacus and his kind to insurrection.

Paid for in blood and earnestness, your spirit can cry, 'I have dared!' Rosa. My Mirror. Twin stranger.

The world is changed without you, but you have changed us most of all.

ROSA! SOAR, ROSA!

ROSA! SOAR, ROSA!
Your spirit will soar wherever there are clouds and birds and human tears.

You were, you are, and you will be. You will remain an angel of history. An angel of the history of possibility.

Soar, Rosa, soar!

I have the sensation that my thoughts are being torn away from me. It seems that life is no longer inside me, not here where I am, but somewhere far off where you soar. Yet I absolutely do not become disheartened. History itself always knows best what to do about things, even when the situation looks desperate.

Soar, Rosa, soar!

When the guardians of order proclaim from one centre of the world-historic struggle to the next that order prevails, they forget that any order that needs to be regularly maintained through bloody slaughter heads inexorably toward its historic destiny; its own demise. A storm and stress, crashing and colliding, is wavering and quaking the foundations of society. Only the resolute will to struggle of the working masses can push away the menacing world conflagration. So let us pursue the independent, bold and fundamental tactics of class struggle. Let us pursue freedom! Freedom is always and only freedom for the one who thinks differently.

Think differently!

Marxism is a revolutionary worldview that must always struggle for new revelations. Marxism must abhor nothing so much as the possibility that it becomes congealed in its current form. Freedom is always the freedom of dissenters.

Soar, Rosa! Soar!

All that exists deserves to perish. It is the whole point of a revolution that you cannot know what, if anything, can or should survive.

Soar Rosa, soar!
I shall not mourn. Howling is the business of the weak. To be a human being means to joyfully toss your entire life in the giant scales of fate if it must be so, and at the same time to rejoice in the brightness of every day and the beauty of every cloud.

Let us maintain our enthusiasm! Enthusiasm combined with critical thought—what more could we want of ourselves?

Your spirit will soar wherever there are clouds and birds and human tears.

You were, you are, you will be. You will remain an angel of history. An angel of the history of possibility.

Soar, Rosa! Soar in the brightness of every day and the beauty of every cloud!

NOTES

In imagining and ventriloquising the unknown words of Carl Einstein, I have imagined that he might in turn have ventriloquised Rosa Luxemburg. All the words attributed to Einstein in this oration are quotations or very slight adaptations of quotations taken directly from Rosa Luxemburg's writings, as identified below. The only exception is the repeated motif, 'Soar, Rosa, soar', an anagram that evokes the idea of freedom and is intended as a materialist counterpoint to the religious notion of the soaring spirit, and as a revolutionary counter to the frequent use of the word (a Google search will confirm this) in the titles of many capitalist and neoliberal manuals for so-called self-help and self-improvement.

Wherever there are clouds...
Luxemburg wrote in a letter to her friend Mathilde Wurm, 'I feel at home in the entire world, wherever there are clouds and birds and human tears'.

You were, you are, you will be...
'I was, I am, I shall be!' were Luxemburg's last known words. In her final text, *Order Prevails in Berlin* (1919), written just after the Spartacus uprising was crushed and in the hours prior to her arrest and murder, the final sentence is: 'Your order is built on sand. Tomorrow the revolution will rise up again, clashing its weapons, and to your horror it will proclaim with trumpets blazing: I was, I am, I shall be!'

An angel of history...
This alludes to Walter Benjamin's literary image of the angel of history. Walter Benjamin and Carl Einstein were contemporaries, and both took their own lives within weeks of each other in 1940, during attempted escapes from Nazi occupation.

The history of possibility…
The writings of Rosa Luxemburg summon an acutely mournful awareness of what Perry Anderson once termed 'the history of possibility'.

I have the sensation that…
Luxemburg wrote in a letter to Leo Jogiches in 1899: 'I have the sensation that my thoughts are being torn away from me'.

Life is no longer inside of me…
On 10 September 1904, Luxemburg wrote from Zwickau Prison to her friends Karl and Luise Kautsky: 'Life plays an eternal game of tag with me. It seems to me always that it's not inside me, not here where I am, but somewhere far off.'

I absolutely do not become disheartened…
Luxemburg, in a letter from Wronke Prison in 1917 to her friend Marta Rosenbaum, wrote: 'I absolutely do not become disheartened. Dearest, history itself always knows best what to do about things, even when the situation looks desperate.'

The guardians of order…
From *Order Prevails in Berlin* (1919).

A storm and stress…
From *The Idea of May Day on the March* (1913).

Let us pursue the independent…
From *What Now?* (1912).

Freedom is always…
'Freedom is always and exclusively freedom for the one who thinks differently.' From *The Problem of Dictatorship*, chapter six of *The Russian Revolution* (1918). This is sometimes translated more concisely as 'freedom is always the freedom of dissenters'.

Marxism is…
From *The Junius Pamphlet* (1915).

All that exists…
Luxemburg wrote in a letter from prison in 1906: 'All that exists deserves to perish. It is the whole point of a revolution that you cannot know what, if anything, can or should survive'. The first sentence is a quotation from Goethe.

Howling is the business of the weak…
From the same (1906) letter from prison.

Enthusiasm combined with critical thought…
From a letter sent from prison in 1918.

MY DEAREST ROSA

I STAND HERE AS JESUS CHRIST, hero of martyrs and suicides.

Upward pressure from the streets scrapes wooden chair legs on tiled floor to stand and shriek.

Your temple, battered to pulp by rifle butts, is risen from the river.

The revolution committee of worms works even now to rematerialise you.

I butter my tongue with metal waiting in the shadow of this burning metamorphosis.

This sorrow drum of nails breathes now ruddy black and plastic.

Better to leap from the bridge of time than to bump along a low ceiling with clipped wings.

A caterpillar and a gun unfolds on a flower from my monocle eye.

I paint your unavoidable face, Rosy, in the pink.

Let it be so.

TAKE A MOMENT FOR YOURSELF

FIRST LET ME EXPRESS my condolences for your loss
I've never met you but I know how you feel
it may seem overwhelming at first
but don't worry I've delivered more than my fair share
of orations
and I've collected tips along the way that
hopefully I can make it easier for you

the first thing you need to do
you need to take a moment for yourself
so sit down with both feet flat on the floor
hands on thighs
neck and shoulders slightly back
make sure you won't be disturbed
allow yourself to gently close your eyes
and think of a time in the past when you felt calm
clear
focussed
it may be a real time or an imaginary time
pretend that you are back in that time
see what you saw
then hear what you heard
feel how good you felt
then take that feeling into what you will be doing
because everyone at the service wants to remember
the one who is gone
and you're going to help them do exactly that
they'll be glad you spoke
everyone wants you to do well
it's also
just to reassure you
it's one of the easiest speeches to give
it's the only speech you'll never be heckled

no one will criticise you
challenge you
you will never have to feel the pressure to be funny
they'll be in your corner all the way
because you will be helping them
to process
to give meaning to it all

because people have to write them at such short notice
orations tend to be too long
people tend to feel pressure
to want to tell an enormous amount about the life
and they end up writing a CV almost
of such lengths that even the people in the room
they start to get bored
I suggest
you should start by thinking about how
about the reaction when you've finished
when the service has ended
would you actually like your few words
for them to have been relatively light-hearted
to remember the life of the person in a joyous way
that will have the people in that funeral smiling
and to create a balance to some of the less pleasant parts of the service
on the other hand if the death has been fairly sudden
or relatively tragic then you may find that this is completely
inappropriate
for people to smile
thinking about the reaction you would like
will help you gauge exactly the way
to put those words down on paper

by all means talk about hobbies and interests of the person involved
somebody who was passionate about football
it would be completely wrong not to mention football
but again not too much detail
keep the thing relatively high level

it's even more important than with any other speech
to keep your sentences incredibly short and easy to deliver
give yourself room for lots of short breaths
split longer sentences into two lines with three dots
just to remind yourself to breathe
and write it in a way that enables you to look up
to show them that you're not just reading
from a bit of paper
that you're talking from the heart
then glance down very quickly
to register where you were
where you are
gather your thoughts
go again

I know
it can seem quite strange
to stand in front of your mirror
to rehearse your speech
but I'm also aware of how crucial it is that you do so
not only will you become more comfortable
with what you're saying
but also you'll see where in the speech
you are going to become emotional
and that way you can take a deep breath
or have a sip of water
to help you get through that part
and it's okay to cry
people worry that crying will take the place of their words
but you're up there speaking about a person who you loved
who has died
you're emotional
it's okay to show a bit of that
but have a back-up plan
even if you don't need to resort to it
it's good to have someone towards the front
of the room who has a copy of the speech

and can fill in for you
if you become too emotional
I'm lucky enough to have a best friend
she looks a lot like me
so when we're both in black dresses
if she needs to fill in she can
I've got people in the back row
won't even know the difference
just teasing
I've also had my six-foot brother
he's been waiting in the front chairs
ready to go

and finally please remember that you can't
think about writing and delivering separately
they're one and the same thing
you're writing to make the speech easy to deliver
and if you think of it that way
then it should all work out

I hope these tips have been helpful
just remember that emotion is not a bad thing
and be reassured that you have complete support
from the people listening to you
and if the speech comes from the heart
you have nothing to worry about
have a look at the handbook for further tips
and feel free to get in touch anytime
if you'd like to talk through what you're planning to say

38 SENTENCES FOR ROSA LUXEMBURG

I. Money is never merely money, just as a canal is never merely a river.

II. We arrived in the magnificent orchards in early childhood, soon after dawn.

III. You ate apple butter and preserves of different kinds.

IV. Locks and weirs dam the rivers into great lakes on which, sometimes, there are birds.

V. The all too familiar conjuring trick in which the Kaiser's irreplaceable pocket watch is replaced by another irreplaceable pocket watch.

VI. Is it possible to be only a minor iconic figure?

VII. If $(v + s)$ decreases as a whole, so too do violets and scabious.

VIII. What is death but a vast accumulation of chaotic notes?

IX. We must place our faith in improved machinery, all the various unnameable pistons.

X. When the frosts of autumn came, we picked the last apples.

XI. Those who do not move are forever damp with dew.

XII. These scribblings are not lyrics, trivial, minor or unrelated references notwithstanding.

XIII. All material is scrupulously sourced using a recognised numbering system.

XIV. Marxism is a revolutionary worldview but only from certain windows.

XV. Januar.

XVI. It is much too late to be gentle, but gentleness is nonetheless essential.

XVII. We are but stolen monuments from the looted Chinese palaces.

XVIII. Geese, winter geese, and frozen water.

XIX. [19]

XX. What is history except a bundle of statements
described as history?

XXI. What is history but a series of redundant brackets?

XXII. They will index your grave with the memorial
ID 8113053 on 22.11.2003, a Saturday.

XXIII. []

XXIV. I.6,000 + II.1,715 = 7,715 to I.7,629 + II.2,229 = 9,858, *etc.*

XXV. Geese, winter geese, and frozen water.

XXVI. A′, A″ and A‴ as well as B′, B″ and B‴.

XXVII. [a]lways

XXVIII. [e]ver

XXIX. [a]non

XXX. There is no minimal and no maximal programme
butΩthere is no sense in looking neither up or down.

XXXI. This is a very peculiar Prussian lever which I will now
describe to you.

XXXII. In a diagrammatic exposition of accumulation,
the rain water from the mountains collects in artificial
ponds on which, sometimes, there are birds.

xxxiii. In this bad, sensationalist novel, the worst passages
are highlighted in yellow.

XXIXV. Yellow apple, red apple, red, red apple.

XXXVI. Telegraph wires bridge deserts on both sides
of that dark water.

XXXVI. Answer this clearly, if you can, Sismondi, or else
go play with your wine and tobacco.

XXXVII. Men of iron, men of coal, men of sugar cane,
men of cotton, men of indigo.

XXXIII. I am not him, Rosa, and we do not have the same initials.

FORMS GROW RAMPANT
A NO GOD'S EYE VIEW OF EINSTEIN'S GRAVESIDE
ORATION FOR ROSA

'The Government took advantage of the demoralisation
to organise repression. The Freikorps units moved in
from the suburbs of Berlin, methodically crushing resistance;
in this they were aided by a "Social Democratic Auxiliary
Force" of S.P.D. stalwarts. Several hundred people were killed
before order was restored, and these included
Liebknecht and Luxembourg'.
'Spartakism to National Bolshevism – the KPD 1918–24',
Solidarity, Aberdeen, 1970

FOR AN ART THAT SHOOTS THE SHERIFF

I'VE BEGUN TO WORSHIP obscene toilet graffiti. Praying to badly
drawn cunts and spunking cocks. The liturgy of this new religion
is always uttered with my tongue flickering on someone's asshole.
But this is not ass-licking like you do at work. I gave up my job
many months ago to concentrate on these words you are now
reading, now making my living from various nefarious activities.
My aim is to make from these words a kind of mass for the
eradication of a special kind of asshole known as the *Spiesser*.

Spiesser is a German word that has no English equivalent,
other than maybe calling someone a 'square'. A *Spiesser* is a
petite bourgeois, philistine, conservative, conformist, and most
importantly an asshole.

The last time I uttered this liturgy on an actual asshole, and
not metaphorical one, was on Sunday, in the toilets of a bar in
Berlin called *Berlin's Over!* After which I spent the day in the bar
writing, drinking coffee, and reading.

I read the words.

'When the bands of artistic speculators had burst apart, the
Spiesser went off in search of their drill-sergeant. They enthusiastically
submitted themselves to the man who repeated the oldest and easiest
to digest catchphrases and worn-out drinking songs. The *Spiesser*

called this their revolution. Now the *Spiesser* was king'.[*]

And write.

We are now entering a new worldwide *Spiesser* revolution with catchphrases like 'hard-working families', 'drain the swamp', 'build the wall', or 'temple' (if you're a right-wing Indian Hindu asshole as opposed to an American Fundamentalist Christian one).

SCHLIEREN (STREAK) PHOTOGRAPHY 1919

A child, or, a very small lady, or old man, holds a two-dimensional movie camera. It appears clumsily rendered like a child's drawing, lacking symmetry, despite its lens and parts apparently being made from the proper materials, like forged glass. The body, which has only a face, resembles the hand mirror from Magritte's painting in which he'd hidden our corpse. A whirling sound, like film spinning in the camera can be heard, as the indiscernible operator cranks a two-dimensional lever anti-clockwise. While, holding the handle of the mirror-like-camera. Slowly panning across the front of the funeral procession, it then focusses directly on us.

Some speculated later that the whirling sound actually came from the camera operator's open mouth.

Cut to a scene of a vast blurred crowd. It shatters like a bad preset effect on video editing software no one uses.

On the flickering screen, we cut to scrolling titles, which read:

Germany 1919...

Workers! Citizens!

The downfall of the Fatherland is imminent!

Save it!

It is not threatened from outside, but from within:

By the Spartacist Group.

Strike its leaders dead!

Kill Liebknecht and Luxemburg!

You will then have peace, work and bread.

Signed 'The Soldiers From The Front'

(*Freikorps*)

We then cut to a mass of joyless pleasure, smeared, writhing and stretching with increasing velocity. The ritual rapidity needed to bind works of deadly peace. Stuffed *Spiesser's* chests bloat as medals are pinned on them.

I pause and write, 'Good taste, decency and those who appeared with brooms after the riots in London need to be decommissioned'.

Then I put some words in Carl Einstein's mouth. 'For the death of Rosa Luxemburg we should create a discipline that treats the white man as if they were already an extinct race. The type of person who cares more about hygiene than the murder of the poor must be put in a kind of museum. Sealing these middle-class hordes behind glass, to be gawped at by lost tribes of limping savage messiahs, juvenile delinquents, tropical fish, and insects. Through the corridors would flow a form made of piranha teeth, wasp stings, children's laughter and berserk dance moves creating an eco system to imprison the *Spiessers*.

The God of every middle-class man lets out a scream that travels at 3.5 km a second. Simultaneously everything is encased in diamond shards. The image shatters into an angular crystalline cohesion. The scream now moves at 120 km per second.

The child or small lady or old man holding the two-dimensional movie camera keeps turning the lever.

THE SYMPTOM IMAGE
(OR THE REIFICATION OF EINSTEIN'S CORPSE)

Now we see a clip that seems to last for hours. The footage shows doctors and their teams performing plastic surgery on a patient's face. As they finish and begin to wash up, a masked group enters and swiftly slits their throats, killing each of them. The killers seem as precise as surgeons. The murders enacted in seconds. This group then removes their fatigues and balaclavas, adorning surgical masks and gowns; they resume operating on the patient's face.

A similar group enters, but this time with handguns and silencers, and carry out a similar operation. (Cut) The camera pans over the patient, starting at the toes, where a tag reads:

'Carl Einstein. Date: 1940. Found under a bridge', and then in capitals 'CONSTANTLY RESUSITATE'.

Panning up to the face: the patient's deeply scared features seem to spell out a stream of meaningless words. The 'O' in one of the words amongst the babble of facial features widens and utters, 'Evidently art-making comprises many elements of cruelty and assassination. For every precise form is an assassination of other versions: mortal anguish cuts the current. More and more reality is decomposed, which makes it less and less obligatory; the dialectic of our existence is reinforced... it is a traumatic accentuation... operative violence... arm the savage arts... or...'.

We cut to the now dead economist Joseph Schumpeter, who winks and says, 'Capitalism's creative destruction has fused life and art'. I order another coffee brought to me by a chain of, among others, landless peasants, logistics workers, and the staff of the café where I sit and write...

STILL LIFE WITH SKULL, LEAKS, AND PITCHER

The hunched figure turns off the projector and returns to the piles of notes, documents, ledgers, and paper debris, on which a skull sits, leaking plant life still encased in diamond shards. A glass jug sits nearby, in which the water seems to be moving in indiscernible ways. Parts flow in alternate routes, while other parts swirl in opposite directions. A file is pulled from a ledger. A section of the file on political murders is circled that reads:

'Political Murders Committed
(January 1919–June 1922, Germany)

By Persons belonging to the:	Right	Left
Number of political assassination committed:	354	22
Prison sentences for murders:	24	38

(Source: *Vier Jahre politischer Mord*, E. J. Gumbel)

The curved archivist, casting a shadow approximating a question mark, pulls out another file. It's titled *Jan Valtin, Out of the Night: Autobiography of a member the Spartacist Youth League*. It

reads, 'Mutiny in the Kaiser's Fleet [...] I saw women who wept and laughed for their men [...] That night I saw the mutinous sailors roll into Bremen in a caravan of commandeered trucks – red flags and machine guns mounted on trucks. The population was in the streets. From all sides' masses of humanity, a sea of swinging, pushing bodies...'.

The figure then hunches over a notebook that reads, 'Cubist Invocations Within The Form-Field'. Books are scattered across the table. Some depict kinds of archaic pornography whose profanity has long eroded, like the broken dolls prized for their inoperative features in Benjamin's child's play commune. These include disembodied genital-like deities, oscillating somewhere between archeological divinities and toilet graffiti. While other volumes cover arts now forgotten and political pamphlets. The hunched figure (who is maybe me) then scribbles, 'The absence of all meaningful value is the freest form of use value?' But who am I?

PART i. A NEOLITHIC CHILDHOOD IN ABERDEEN INSCRIBED INTO GRANITE WITH CROCODILE LOGOS

When I was young I needed to fit in. I needed to belong. I needed release. So I joined a gang. We were skinny fay boys with floppy fringes, kids from the schemes who adopted the attire of the upper classes. Like deerstalkers hats and waxed Barbour Jackets popular with the landed gentry, though worn with the corduroy collar buttoned up, but the jacket unzipped. So, with your hands in your pocket, you cast triangular shadows. Angles were important. Your hair, the angle of your fringe, and the wedge or step cut into the back. We would shatter the peace of city centres on Saturdays. A breakdown of the mass in busy shopping centers would radiate lines of flight, bodies rushing forward. Faces snarled and excited by dread and adrenalin. We liked Italian and German sportswear, and I liked modern art. These scenes reminded me of Italian Futurist paintings like *States of Mind—Those Who Go* by Umberto Boccioni (1911). 'The different lines of a vase of flowers can follow one another nimbly while blending with the lines of the hat and neck', as Boccioni

said. An Edinburgh teenager was put into a coma, and business cards reading 'Aberdeen Kicks To Kill' were printed. Aberdeen is made of grey granite, had some of the highest house prices in Britain during the 1980s due to the discovery of North Sea Oil, and suffered from an emotional plague. This plague roams the earth encasing it in middle-class forms of life.

I finish my last cup of coffee and let out a scream as I'm encased...

* Carl Einstein, manuscript, in David Quigley, *The Fabrication of Fictions: A Defense of the Real*, Vienna: Pakesch & Schlebrugge, Verlag fur Kunst und Literatur, 1999.

BOUQUET

LAVENDER ROSES AND PINK LILIES with Eucalyptus. White Roses and other soft white and green blooms. Orange Roses, White Chrysanthemums, green Cymbidium Orchids, and bronze Hypericum. Cream and pink Roses, pink Cymbidium Orchids, Hydrangea, Phlox, Lilies, Hypericum, purple Freesias, and cream Anthuriums, with Anthurium and Aspidistra leaves. Red Roses with Asparagus Fern and Palm leaves. White Roses, scented Freesias, Chrysanthemums, and Eryngiums. Pink and cream Roses, pink and purple Phlox, pink Lilies, and Hydrangea with foliage. White and cream Roses, Hydrangea, Lisianthus, Carnations, and Viburnum. Pink and white roses with pink Oriental lilies, blue Eryngium, white spray Chrysanthemums, lilac September flowers, and foliage. Large-headed Roses with Aralia leaves, French Ruscus and Eucalyptus, Cymbidium orchids, and green Anthurium, pink Calla lilies, Veronica, finished with Aspidistra, Aralia leaves, Palm leaves, and China grass. Pink and green Roses, pink Hydrangea, and Sweet Peas. Pink Roses, purple Carnations, and Astrantia, pink Hypericum, Lisianthus and Hydrangea with ferns. Pink Roses with variegated Ivy and soft Ruscus. Deep red Roses, spray Carnations, and Hypericum berries mixed with purple Statice and Lisianthus. Roses in varying shades and sizes, with Sedum, Eucalyptus, and Pittosporum. Baby pink Roses, Larkspur, Alstromeria, and Lisianthus. Pure white Roses with Aspidistra leaves, Sanderiana, and Bear grass. White Roses, Freesia, Carnation, and Chrysanthemum flowers. Memory Lane Roses, Cream Germini, White Freesia, Green Carnations, and Chamelaucium. White Roses, Carnations, and Waxflower. Yellow Roses, Carnations, and Solidago flowers. Pink Roses, Lisianthus, Liatris, Statice, Carnations, Waxflower, Aspidistra, Eucaluptus, and Bear Grass. Avalanche Roses, Lisianthus, white Eryngium, and Alstroemeria, with fragrant Eucalyptus and Leather leaf. Orange and cerise Roses, purple Aconitum,

pink Hydrangea, green Anthurium, and orange Gerbera, with Molucella, red Cordyline, Aspidistra and Aralia leaves, Cocculus, and red Dracaena. Red Roses, Gerbera, and Carnations, with green foliage. Orange Roses, orange Lilies, and orange Gerberas, with blue Lisianthus. Pink aqua roses and pink Alstromeria, pink Gerberas with pure white Chrysanthemums. Cerise and orange Roses and Carnations with orange Germini, purple Anconitum, and green spray Chyrsanthemums. White Roses, blue Iris, Lisianthus, Chrysanthemums, purple Trachelium, Eryngium, Bupleurum, and green spray Chrysanthemums with Rosemary and mixed foliage. Large pink roses and white Aster flowers with green foliage. Palest grey Roses with winter foliage, seed heads, Astrantia, and Eucalyptus pods. White Roses, Carnations, Gladioli, Stocks, and Oriental Lilies, with green Molucella and foliage. Red Roses, Gladioli, Anthurium, Aranthera Orchids, and Hypericum berries. Peonies, Lithianthus, Roses, and Viburnum. White Hydrangea, dusty pink Rose, white Wax flower. White Avalanche Roses and large-leafed Eucalyptus. Coral Peonies, cerise Roses, and sea-green Hydrangea. Pale pink Roses, magenta Vanda and Phalaenopsis Orchids, and lilac Clematis. Pink Rose and Heather with Thyme and Ivy. White Roses, Lilies, Hydrangea, Lisianthus, Chrysanthemums, and Carnations. Calla Lilies, and foliage. Statice, Dianthus, Ageratum, Lilies, and greenery. Pink and cream Roses, pink and purple Phlox, pink Lilies and Hydrangea. Pink Roses, purple Carnations and Astrantia, Hypericum, Lisianthus, and Hydrangea with fern. Roses, Chrysanthemums, Carnations, bronze Hypericum, variegated red and lime Dracaena, Aralia leaves, Cocculus, Salal, and Cherry Blossom. Lemon Roses, yellow Chrysanthemums, and Mimosa. Mauve Calla Lilies, purple Aconitum, Liatris, and Chrysanthemum, orange Germini and Carnations, with green Anthurium and Chrysanthemums, Variegated lime Dracaena, black Cordyline, and Aralia. White and cream Roses, Million Star, and variegated greenery. Green Anthurium, yellow Chrysanthemum, purple Allium and Delphinium, Brassica, and other foliages. Deepwater roses, pink Germini, and frilly pink Carnations.

AN ADDRESS TO THE LIVING ON
THE EVE OF THE FIRST CENTENARY
OF THE SPARTAKIST UPRISING

Note: This introductory fragment is all that survived from an evening-long paper given by Carl Einstein in November 2018. The paper, dealing with the 2008 economic crisis in light of the legacy of Rosa Luxemburg, was transcribed from the original noise of a howling wind that went past a forest on the banks of the Gave d'Oloron in the south west of France.

DEAR READERS, IT MAY STRIKE YOU as absurd to let a corpse address such matters as labour, consumption, and capital, matters that you may feel belong to the world of the living and that the dead should not be preoccupied with. You say: 'Why would you concern yourself with the unremarkable—banal even—misery of labourers in capitalist societies as you lie perfectly still in the soft earth for eternity?' If exploitation, as Marx shows, is built from little units of time, what business would the immortal dead have with such a clearly temporal affair? This is nothing but sheer ignorance on the behalf of the living. The fact is that death is hard work. Becoming one with the earth, feeding the worms, the cycle of life, and other such clichés do not come close to describing the utter numbness, the cold and harsh exhaustion that a dead body experiences at the end of a long day rotting away. We, the dead, turn ourselves into raw materials to be harvested by industry: we are the agricultural soil of today and the petroleum of tomorrow. I do not mean to invoke a religious sentiment—one that I certainly do not share—when I say that only a thin veil separates us, the dead, from you, the dying. And only comrade Platonov alone suspected the existence of this insulting conspiracy but having been made to suffer the kind of intellectual death known as Stalinism for most of his living career, never produced a fully developed economic manuscript on the subject. The fact is that from our point of view, Marxist thought contains a single glaring omission: class decomposition. Underneath the colossal industrial zones of China, India, or Indonesia, beneath the warehouses, the kitchens, the hospitals,

the mines even, we lie, a class more numerous and yet more voiceless than the workers, older than civilisation itself and yet incapable, for the time being at least, of any meaningful form of political organisation.

I hope you will start to appreciate, dear rotters—for you too have started to decay a long time ago—that the realm of work is the realm of death. Work is about the gifting away of the precious life force that each worker possesses. It is removed, stripped even, and handed over to the finance department without ceremony. With this a little death arrives *via* 'internal post'—time without reward but also the death of possibilities, of new openings and new worlds that will now never come to be. As the workers' physical and intellectual power drains out and debt grows, so die the tomorrows that they wished for themselves a long time ago but could never claim. As we continue our rot in the earth, we have no illusions anymore, no yearnings for lost adolescent dreams.

But make no mistake: we have not lost the ability to dream! Although we will not dream of yesterday, we will forever dream of tomorrow, of what could still and must be. Incredibly, despite the physical torture and tedium of disintegration, we have retained the presence of mind to study the world, to listen to the murmur of living workers, to watch stock market crashes, wars, and genocides flare up here and there. My dear murdered Spartacist friend, scattered somewhere nearby, keeps mocking me for still orating about her a hundred years after a bullet entered her brain on a cold Berlin morning. And she is right. We the dead do not dwell in the past like some cheap ghost in a penny dreadful. No! Our feet are lodged firmly in the present with our gaze laid upon the future. We collect all there is to be gleaned from capitalism at the same time that inside our bodies grow the seeds of a world beyond it. We collate information, produce reports, and decide on the best course of action in our pauper grave think tanks. We whisper our recommendations into the wind that gently shakes the leaves of the trees. Most of you, my somewhat living readers, will not notice and would not know how to read the subtle music of economic analysis as it writhes through tree tops in the park. But somehow, quietly, quietly, a faint noise settles in the mind like odourless sediment. From the dust of this music, our new Jerusalem shall be built.

So today, I will not look at our glorious struggles and many mistakes, but to the present, to the current state of the world. Rosa and I have had many illuminating conversations over the decades and I would like to offer here a few sketches that might at some point in the future serve as the basis for a new and elaborate edition of her writing, extended into the twenty-first century. Rosa's most wonderful contribution to our understanding of capitalism in the 1900s was her insight that the brutal violence of this economic system cannot be limited to places and processes of production. Only by reconditioning the bodies of workers to absorb an ever-growing quantity of surplus commodities, by organising entire pre-capitalist societies into societies of private ownership and consumership, by subsuming more and more forms of life in an expanded field of labour, can capitalism progress in its unyielding quest for infinite re-investment. In short, we must look at capitalism as a system of accumulative consumption that must constantly conquer more ground and possess both body and soul: through consumer credit, consumption corrodes the future; through supersizing, consumption clogs the arteritis.

But we can now see that this violence which lasted for nearly three hundred years has been nothing but an agonisingly slow death for a commodity-based capitalism. This became most apparent over the last decade—a decade of negative productivity growth, of austerity, of interest free giveaway money to banks. Debt continued to be a way of life, but now there is no maxing out of credit cards to fund fraught consumerist rushes like the ones in the 1990s. There are no more cheerful bargain bin luxury brands, no more holiday packages, no more triple re-mortgaging of assets. There is only a desperate blind stumbling towards a dwindling pay day of a squeezed middle class that can't hold on to a disappearing life-style option. Unable to fund the newly privatised zones of education, health, and other social services, this middle class now fights to preserve a shred of what defined it as a socially cohesive group: good taste, participation in cultural events, private ownership of property, and family life. It is almost ironic to see you, the living worker, imitate our complete uninterest in the commodity. It is obvious that the dead have little need for perfumes, cars, and shoes, and no desire to acquire anything. Yet it is quite a different matter when the living

develop the same commodity aversion as we, the same bored
dull gaze when presented with the latest marketing campaign
for an energy drink or a smart phone. But, my dear readers, my
final preliminary remark tonight before delving deeper into
twenty-first century economic policy is that we the dead have
not remained hollow or lost. We do not need commodity desire
because we are full of a burning desire towards a future that must
and will come. When we look into the night above your living
cities with their crowded streets, we see nothing but this future
and we want nothing more.

CANALS 2018

➤ Landwehrkanal, Neuköllner Schifffahrtskanal, Britzer Verbindungskanal, Zehlendorfer Stichkanal, Teltowkanal, Spreekanal, Kupfergraben, Berlin-Spandauer Schifffahrtskanal, Westhafenkanal, Charlottenburger Verbindungskanal.

➤ DIALOG ETHIK, in thick black marker on a mattress dumped on the bank.

➤ Four lurid orange bike-sharing bikes tossed into the canal from the bridge, dimly visible on the bottom.

➤ A stretch of the Teltow marks the boundary between Berlin and Brandenburg. The Wall ran along this part, on the south bank, discernible in a long ditch and occasional outcrops of concrete and steel obviously too stubborn to extirpate. The whole area cluttered with brush and thirty-year-old trees.

➤ A Hobbiton of shacks and cabins. Dachas for workers.

➤ Hop through a window and pick our way through fire-blackened rooms to emerge in a vast ruined warehouse, a square kilometre of empty space. The security guard catches us at it but is happy to stand and smoke a cigarette while we poke about.

➤ No towpaths, Felix notes.

➤ An American Football ground. Hubbub of a match in full swing.

➤ Little neighbourhood bars, Eckkneipen, fittings and décor changeless as a grandmother's front room. A nice custom: a man comes in and glances round, then on his way to the bar raps briskly with his knuckles on the corner of any occupied table, even yours, a stranger's. Some people tap back.

➤ AFD ONLY, scrawled in English on the gate into the allotments on the Britzer.

➤ Blue frost. A crow strops its beak on an iced-over puddle.

⤙ Far out of town, the stump of a violently amputated bridge—bombed? Why wasn't it rebuilt?

⤙ One particularly jaded-looking llama.

⤙ Two American eagles.

⤙ The Lichtenstein Bridge. *Der Landwehrkanal wird nicht rauschen.*

⤙ A sort of jetty on the Landwehr up the way from Tiergarten. On it is a chunk of iron that must have had an important function but has been so brutally truncated it's impossible to discern what it was (crane? foundation of a bridge?). And, alongside each other – like his and hers Bauhaus tombstones – two metal oblongs on low platforms of brick, on each one a single word: RECHTS and LINKS, right and left.

⤙ Bright blue May morning: a barge heading into the city laden with grit for cement honks its klaxon at us.

⤙ *Thorium not Uranium.*

⤙ That feeling as a jogger pounds up behind you, your body tense for the impact.

⤙ On the Teltow, past where it is crossed by train tracks and a motorway bridge, in a nominally unwalkable section, there is a compact structure with a heavy metal door in the scrub on the steep bankside. I heave open the door, throwing light into a dark space the size of one of those capsule hotel rooms. Someone inside wakes with a start and sits bolt upright.

⤙ A woman, middle-aged and completely naked, squats to pee in the undergrowth on the opposite bank, one hand clutching a sapling.

⤙ The port at Westhafen calm and deserted on a Sunday. Chivvied out by security nonetheless.

⤙ A confederate flag billows above the allotments. Nazi iconography being illegal.

⤙ Used needles like snakes in the leaves beside the path.

⤙ In summer, boats pass every fifteen minutes along the

Landwehr, top deck full of tourists in pastels and cream. Some blast pre-recorded commentary, meaning that if you are sitting on the bank you hear the same snippet describing where you are several times an hour.

➤ Just up from where the Landwehr meets the Neuköllner, the bridge and banks are crowded with people and emergency vehicles. There's a police boat in midstream and two divers methodically working their way along the canal, swimming diagonally from one bank to the other, staggered but on the same trajectory.

➤ Snow trying and failing to settle. The squalor that ensues.

➤ Building, building, building, on every available scrap of land.

➤ Sleek ranks of newbuilds (offices, flats, bureaucracy) periodically interspersed with redbrick Gormenghasts, once factories or breweries, some derelict and overgrown but most now carved up into open-plan chambers flooded with fluorescent light, labour's permutations, in which people are paid to sit quietly and perform the same range of minute physical gestures, the same few mental operations, somewhere between catatonia and satori.

➤ Delivery vans come and go like bumblebees, bike couriers like hummingbirds.

➤ In their youth old people learned to waste nothing. So on Sunday they throng the banks to throw stale bread to the ducks and swans, who are already full and only mildly interested. Bread is bad for them anyway.

➤ A special kind of boat dredges the canals once or twice a year. From time to time it dumps out the bits of metal it has scooped up—readymades of rust and mud, warped bike frames, shopping trolleys, unidentifiable bits and pieces, which sit there on the bank for a few days until the *Stadtreinigungsbetriebe* trucks come for them.

➤ A man is being followed by crows in uproar. From time to time he throws them a walnut.

꙳ A desire path ratified with woodchips. Another blocked by a peevish boulder with a subsidiary desire path around it.

꙳ Inadvertent (unconscious) brutalism of the undersides of mid-century bridges.

꙳ *Allah ist der Beste.*

꙳ Judgey Prussian visages.

꙳ Near the airport at Tegel, on the Schifffahrtskanal, a long section of concrete wall, which looks like Wall but can't be, covered in graffiti. Piles and piles of empty spray cans.

꙳ Glossy conkers dot the pavement, inducing a kind of accumulative frenzy. But by the time you get home they are dull and worthless, as happens with pebbles picked up on the shoreline. You stuff your pockets anyway, knowing this.

꙳ I count forty-nine swans from the Köttbusser Brücke; who even knew there were that many swans in the world.

꙳ Walking home through Kreuzberg along the Landwehr late one evening, S. and I come across a man holding a clarinet, arguing strenuously but quietly with an older German couple. He has various followers with him and one explains that he wanted to play a duet with a nightingale that has its nest there (we ourselves had heard it a few hours before, and had hoped to hear it again). But the old couple came out of their house to tell him to stop, that he was permanently warping the nightingale's song. We walk on.

WHAT DID HE DO WITH HIS PIPE?

Transcription of typewritten document with annotations.
[Completed 3 March 1987. JPH.]

SYNTHESIS OF WITNESS ACCOUNTS by SM and GS of the speech given by Carl Einstein at the funeral of Rosa Luxemburg. Filed on 27 June 1919 by WM.

(1) The previous speaker left the podium, and the fourth speaker [Carl Einstein] stepped briskly forward and placed his pipe on the lectern.[1] CE cautiously approached the speaker's position. A small lectern draped in [red] fabric had been set up. Taking his pipe from his mouth with his left hand [Einstein] placed it on the lectern. He made a gesture acknowledging the previous speaker. CE pointed toward her, and partly inclined his body, before turning to the front.[2] CE took some papers from the [inside] pocket of his jacket [from the right pocket he took a single typewritten sheet].[3] Einstein wiped his glasses [with a pale-coloured handkerchief] [on his jacket lapel] and replaced them on his nose.

(2) Standing quite still for a moment, Einstein inclined his head, with arms along the sides of his body. Then he sorted his papers. CE smooths the sheet and holds it at arm's length in his left hand. He raises his head and while speaking his opening phrases looks out toward the crowd. He shakes his head twice right to left, then raising his right hand and opening the palm broadly he brings it down slowly toward his body. Einstein spoke directly to the crowd, and then deliberately read a list or series, marking the enumeration with a pointing right index finger on the sheet. CE points to Luxemburg's coffin. Then looking up and out he makes a grabbing gesture with his right hand and arm. This is followed by a gesture of calming, as he passes his open right hand palm downward across the space in front of him. Einstein turned and nodded to his left and right to indicate the others on the podium.

Facing to the front again, CE brings his right arm diagonally across and then up, with an opening palm toward the sky. He pauses.

(3) Taking the [sheet of] paper[s] into his right hand, he points at them with his left index finger, then he gestures briefly to the left and to the right with an open hand. [...][4] CE holds both arms wide apart, then brings the hands closer to each other, held at stomach height, and then with his right hand he points sharply to the ground. CE continues to speak, then holds up his left hand palm outwards as if to fend off something, then that gesture is repeated. Einstein made an arching gesture from right to left, with an open left hand, then closing this into a fist he brought it close to his body. He rested both hands on the lectern and leaned forward, looking out and down to the crowd. He stood erect again and paused in his speaking.

(4) Moving his papers to the left hand, CE makes a gesture of wiping or cleaning them with the right, making three passes over the sheets. Then with thumb, index, and middle finger together he sweeps his hand sharply to the right, with elbow raised. This is followed by a slower gesture with an extended arm, moving in a wide curve to point obliquely behind and to his right. Holding his papers close to his chest with the left hand, CE reaches forward with the right and makes a grasping movement, then brings the arm back and forms the hand into a pinching gesture. Einstein pointed to the sheet he was reading from, pressing on it with his right index finger, and then raised his arm, and passed his right hand with palm flat across the top of his head.[5] Einstein frowned and then pointed down to the left and down to the right. [...][6] Looking out to the crowd he made a gesture with his right hand palm pressing downwards; he then raised the arm and made a sweeping gesture to encompass all before him.

(5) Einstein looked back to his notes, and turning a sheet with his right hand he looked up. With the right hand held at chest level he indicated a gap between index and forefinger, and then made a curving gesture out and back to the chest with the hand

stopping flat below the shoulder. He brought his right index finger to the temple, and then reached out with an open hand in a stop gesture. He continued speaking quickly throughout. CE pauses then with eyes downcast. Then bringing each hand up with open palms he looks out to the crowd. Pointing to the extremity of the crowd, he looks into the far distance beyond the trees, and then points behind him first left and then right.[...] He followed this with a series of chopping motions of the right hand, and then a grasping gesture into a fist, which he brought down sharply to hip level. Then pausing, Einstein took his glasses and wiped them with a cloth.

(6) Looking down briefly he began to speak again. A sweeping gesture of the left hand at hip level followed, this was followed by a flick of the hand out to the left. Einstein then struck his chest over the heart with his right hand in a fist, and then taking this fist he made a gesture of casting away to the right side. CE brings both arms out in a sweep to encompass the crowd, and then both arms are raised with palms open to the sky. Einstein circled the right index finger pointing upwards, the hand and arm rising above the head. Then he returned this hand to waist level with finger and thumb pinched, arriving to the left of the body. Then CE opens and moves the hand slowly and smoothly to the right. He sweeps the left hand in an arc from low at the right hip, across the body and out to the left at just below shoulder height.[...] Pausing to pass his papers to the right hand, Einstein made a dismissive gesture with the left, then raised the left hand, palm facing right and brought arm and hand down in a sharp slicing motion. CE looks out to the left and the right, and a point is underlined with an interrogative raised finger, and then a second finger is raised, and then a wave outward in an indication to the crowd, followed by a gesture back to the centre of the city.

[7] Einstein passed the papers to his left hand. He made a negative gesture with his right hand with a sharp crossing action. A gesture out to the crowd followed, curving as if to elevate or raise them. Then Einstein with his right hand in a grasping action

raised it above his head, and brought it down in a fist, sharply. A pause followed.

(8) Einstein held his right hand out to the crowd, with the palm cupped upward. Then he moved the hand twice in a gathering action, a tight circling of the hand down and toward the torso, then up and out from the body, and then brought to the chest over the sternum. The left arm was then moved in a curved sweep out to the left, obliquely, and he brought both hands together in a closing action. CE holds both hands out toward the crowd, then brings them back toward the body closed into fists. Then with the right he points to the coffin. Einstein made a series of three chopping motions with the right hand, as the left was raised to shake his papers and then lowered. Then with his right CE again points to the crowd, and to the coffin, and then in a fist he raises it to the sky. Briskly then Einstein folded the paper[s], [picked up his pipe], and turned to allow the next speaker to approach.

WITNESS COMMENTS:

SM: The witness was observing from 'too great a distance to hear the speeches made'.

GS: The witness's 'view was partly obscured by taller individuals and banners' and limited notes were taken 'to avoid arousing suspicion'.

NOTES ON THE MANUSCRIPT

1. Einstein was the second to last of the six speakers according to witness GS. [comment in left margin in ink].

2. Did he keep his hat on? (KGM) [pencil annotation on the sheet].

3. The number of sheets is inconsistent in these accounts, nor is it clear if they were typewritten. [comment in left margin in ink].

4. What's missing here? (KGM) [pencil annotation on the sheet].

5. Had he taken his hat off at this point? (KGM) [pencil annotation on the sheet].

6. There appears to be a short gap in both accounts at this point. [comment in left margin in ink].

7. How does the witness know this? interpretation? (KGM) [pencil annotation on the sheet].

'AND NOW, IN ALL SERIOUSNESS, A KISS. YOUR R.'

ROSA, THE WAY YOU SIGN OFF YOUR LETTERS. This struck me when I first read them with DH, sitting on the top floor of 53 Gordon square in November 2011. We read: 'I kiss Dziodzio, my Ciucia. R. [...] Be quick about writing, and write about everything. R. [...] I do not kiss you. [...] I warmly press your hand [...] A little kiss on your little mouth. Your wife. [...] Dziodzio, dear, I throw my arms around your neck and kiss you a thousand times. I want you to pick me up and carry me in your arms (but you always have the excuse that I'm too heavy). [...] You incorrigible diplomat! I have to close now, for today. I kiss you strongly, right on the kisser. Your Rosa. [...] Because of the situation at home and the constant little obstacles to getting work done (such as this trip to Upper Silesia), I'm in a very bad mood. Kisses from the heart, Your R. [...] I kiss you on the nose.'

The student movement was waning—we had had appropriated the building, destined to become a graduate-centre, on 23 November. The top floor, where we read the letters, would be a luxury apartment for a new Dean of graduate studies. The building had been empty for three years, subject to a dispute of ownership, but seemed to belong to the School of Oriental and African Studies. Before SOAS management had managed to install anything like card-access, we took the doors, some of us thinking ourselves third generation revolutionaries from the Fassbinder film. It was a botched entrance, and we were flawed: there were still cleaners inside, and our taking of the building would lose them a day's work. We thought we wouldn't take it, but then sixty or so technology freaks from Occupy LSX arrived, forcefully ousting the cleaners. I think it was a mistake, and not one to be proud of. However, the question of whether we ought to take the building—uncomfortable—no longer posed itself. Too late now. We spilled into its grand six floors, peppered with broken asbestos and locked and empty glass museum cabinets.

It had formerly been a Museum of Chinese Art. Someone soon converted them into a Museum of Neoliberalism and reified the reified. Wishful thinking.

Once inside we declared it Bloomsbury Social Centre, a little at a loss, and argued fiercely about what it would be for. A workers' breakfast to engender alliances between workers and students! *But there are no workers in this neighbourhood,* said some idiotic fetishists of industrial production. The students are workers said some well meaning and partly correct fetishists of students and of Andre Gorz. *We can fix all the plug sockets and install* WiFi said the sixty or so Occupy LSX people, who now believed the building was theirs, and had previously left their jobs in the city, and were now camping out in the apocalyptic spread of London Stock Exchange (green wigs, antisemitic conspiracy theories and the Twin Peaks soundtrack on loop). The occupiers flitted around like leprechauns before blowing all the fuses and leaving.

We made a zine library with bad photocopied copies of Tiqqun's *Theses on the Terrible Community* and something called *Kittens* (about French *lycéen* protests during the CPE riots in 2005), and other things. Every night we had dinner plus politics, and every morning we read the *Financial Times* together. DH was reading your *Accumulation of Capital* and we were reading your letters, about how you lived in Paris, and in Berlin, under different names, always finding it difficult to find the right room. You write to Leo Jogiches to send you things. You are stern, impassioned, demanding. He clearly is not equal to your powers of expression, or the depth of your love. Anyway: 'Don't forget to bring the Chartism [book].' '*Prochitai vnimatelno moyo pismo* [Read my letter attentively] and answer all questions.' 'Scoundrel, send me your photograph right away!!!' 'Forward my letters without delay.' 'Be quick about writing, and write about everything. R.'

Questions of money often preclude the differently ornamented kisses at the end of your letters, here with your explicit reflection: 'Aside from the political question, the material problem arises for me of how and where to earn money?! But we will not lose our heads or our cool self-possession. There are greater unhappy

occurrences in life and in political work. I kiss you hundreds of times. Your R.' And when you find the right room in Berlin you tell Leo how much it has cost you. I could not find your house there: the entire quarter was destroyed and then rebuilt in the 1950s.

We draped long red and black banners on the outside wall of the building in homage to the Paris Commune. R-AG and I had just frauded (printed our own) inter-rail passes and gone to Italy and made RAGE, a zine by which we hoped to educate new students as to the winter of 2010, when students had broken the windows of the Tory party HQ at Milbank and occupied their universities. R.AG had a secondhand squirrel fur coat which she had bought with all of her dole money to keep warm and she got in a fight with some of the people who had just fought, very bravely, against the eviction of Dale farm. I joined her in a full mink that I had appropriated from the basement of a costume museum that was throwing out its stock, and a velvet jumpsuit. *Get a total critique*, we said. *We'll talk to you when you stop treating us like coat-hangers carrying clothes around!* They said we looked like *bourgeoises*. Perhaps they were right, and perhaps with more time we would have gathered some more nuance in our pelts. But these conversations about aesthetics were productive, fierce, absurd. We read your letters, peppered with questions of rapid editing for the review, clothes you needed sent: 'Send me the brown dress (and the petticoat) and be timely about it, because I must be at a banquet the French are putting on, on March 18.'

And we said, there's a problem with your conception of capitalism and Imperialism, as if you thought it were a swinging lever, motivated by the wiles and wishes of frivolous women, consumers. There is a problem with the idea that you can only see the bourgeois as a *woman*, walking along the street, unconsciously piled up in furs and shopping bags. Besides, then the queer boys came, and confirmed that in our

outlandish makeup and hair styles (stuffed with stockings), we were about the *only* thing that made them feel at ease there.

This question of clothes segue ways back into the evidently stupid question of whether there are workers in proximity to elite universities in central London, and indeed into whether there are normal people anywhere close to Kings Cross: I grew up there in a housing co-op and attended the worst school that side of the Euston road, and I can tell you that the poorest people were always the most immaculately dressed and done up and embellished in gold creole hoops and sovereign rings, and that there's no virtue in this shit from Cambridge—all those rags and Oliver Twist fantasies about playing poor. To get rid of one's chains doesn't necessarily mean your jewellery: surely the point is to acquire more of it from whomever has more than you do. Second: feminism is not about being cutting out 'femininity' necessarily, and third: that neutral (or at least the same to the other) is often, necessarily, masculine. Such moralism! If I had time I would read you Marianne Moore's poem *New York*, but I think it's getting late and cold at this graveside, and everyone wants to go home. On one of the first nights, tired, and after reading some of your letters in which you speak of blackbirds, singing outside your jail cell, we gathered into a small room and heard Sean Bonney read—also a letter—to Rimbaud, that narrated our recent history. I had that rhythm in my head until at least December, when bailiffs came and cut through it, and the roof of the building, with chainsaws, sledgehammering a comically loony tunes-ish hole into the cornices.

> Dear Rosa, this address cannot be equal
> to what we got from your letters.

NOTES

All quotations are from Rosa Luxemburg, *The Letters of Rosa Luxemburg*, George Adler, Peter Hudis, and Annelies Laschitza (eds), London: Verso, 2011.

EIN STEIN IN MITTEN VON ZEHN GRÄBERN

ONE STONE IN THE MIDDLE of ten graves.
Here lies:
no body

of Rosa.

Let's call that empty pit a grave and her death murder.
What is it that makes a funeral? Ritual or denomination?
The body violated, then disposed. Her head hit
first with a gun butt then by a bullet.
As to make sure, to make sure to leave nothing to chance.
Dumped into the canal, the water runs steady, ripples.
Involuntary complicity of an attempt of erasure of
murder (of a person) in its concrete constructed bed.
Then (I was), now (I am), always (I will be).
Your heart is with the birds; they are
singing your eulogy near the canal.
In the wide streets of Berlin, barricades under
grey skies, finally the exploited are rising up.

Let's imagine the empty casket to contain her body. Let's try.
Let's mourn without evidence but knowledge of her death.
Let's bury that empty box in an empty hole with our hearts
full of love/pain and rage. Burial of a name without a body.
They find her body later. Or not. They find a body in the
waters. Later. Parts of a body. They give to what they find a
name. Two gloves, adornments – commodities of daily life
– are what make a disfigured body a person. Make possible
the act of naming. We act and we put the remains in the
empty casket and bury it again. As to make sure. In the
empty pit we wrongly called a grave before as to reinstate
its meaning. We mourned (I was). We mourn again (I am).
We don't forget. We continue mourning (I will be).

In the wide streets of Berlin, swastikas under
grey skies, now Nazis are rising up.

They desecrate her grave. Later. They smash the
site and take the body we put in the casket. Second
attempt of erasure of a name (of a person), a place.
Where there is no grave there is no body.
Remembrance of nobody.

After the war the site is reinstated. Ein Stein in
the middle of ten graves. No body under the stone
under the metal plate that bears the writing:
Rosa Luxemburg
Ermordet 15. Januar 1919

Later. A pathologist finds a body in the cellar of a
hospital. A body recovered from the canal. Parts of a
body. Forgotten, for almost a century in the basement.
The corpse of a woman with no head, hands, record, or name.

He claims the corpse is her body:
The body we buried after we buried an empty casket,
the body the Nazis took after ransacking her grave,
the one that is now gone, was never hers, he says.
She, he says, is the body that appeared unexpectedly, that
came out from a freezer in the nether worlds of the biggest
hospital in Berlin–almost one hundred years after it was
put there and forgotten. But we said we won't forget.
Nobody knew about a body.
No body was missing and still there is a body. Now.
Somebody must have been this body once, that now could be
the body that should be inside the grave in which is no body.
As a body is missing from the grave the pathologist names the
found body Rosa attempting to close the hole, not the grave,
but the hole of disappearance of her body form the hole.
A third attempt of erasure (of a person).
However, anybody who should be in the grave
cannot be this body, the body from the freezer.

They run tests, are proven wrong.
The body belongs to another one with another name.
One body is not another body. And this body is not her body.
Her grave remains empty.

Your name on a metal plate.
Your heart is with the birds, they are singing your
eulogy. Your words are with us, we must find the
courage to speak them again. *Die Toten mahnen uns:*

In the wide streets of Berlin, in Europe, the World,
torches under grey skies, again fascists are rising.

One grave in a circle of graves. Rosa.
Karl, Ernst, Rudolf, Franz, Franz, John, Walter, Otto, Wilhelm.
Ein Stein in the middle of ten graves.
Albert, Alfred, Karl, Carl

A EULOGY FOR ROSA

OH ROSA, OH DIMINUTIVE NOW DIMINISHED; for you it was always too soon; the civil war we find ourselves within; the weight of this world heaved upon us. And the bourgeois press—that mouthpiece of villainous shit, festering with open wounds—those constructors of public taste that line the troughs with blood, they call us 'the men with knives between their teeth', but now it is as clear as a singular star in the night sky that it is they who let our throats. Under each and any moon they prey upon the defeat of the working class. These 'protectors', celebrating the re-establishment of order, of things simply going on as they always have, when, all across Germany, the aftermath of war has led to a resurgence of the class struggle. In these past few months we have moved through the echoes of our failures. For Rosa, the upheavals arrived too early, and now equally her cries resound much too late. Yet, all of us that are here for comrade Rosa know that she taught that the spirit of revolution moves through its defeats. And here I call upon you to move with me, as all across Europe and the wider world, the masses are starting to heave with their own weight.

While there is much we do not know about the murder of comrade Rosa Luxemburg, there are many things that shine clearly. First, we know that her death was carried out by the most reactionary elements of the military in support of the counter-revolution. Furthermore, we speculate that it was carried out under the executive of senior officers. Therefore, I state comprehensively that the murder of comrade Rosa stands as an act of aggression not only against members of the league, not only against the most militant elements of the Berlin proletariat or the broader workers' movement, but that the bullet that killed her is violence against the class as a whole, even as it now lies in separation. We know that the devils who apprehended Rosa had so little regard for our comrade that they smashed her in the face with a rifle butt before they shot her through the head and dumped her corpse in the canal, as if

she was little more than meat to be fed to the dogs. In spite of the rumours of angry mobs that ring through the gutters of Berlin, we know that it was the military who seized comrade Rosa from her house on that fateful January evening. However, in spite of the dirt and lies spread through the air by enemies and class traitors, while the organised proletariat can be sure of these things, what we do not know is perhaps most pressing of all. All that can be stated is that the military, the judiciary, and Ebert and Noske's government all have blood on their hands.

I have heard of rumours from comrades that when Rosa was taken she had a copy of Goethe's *Faustus* in her handbag. And surely we can state that those supposed friends of the class, Ebert and Noske, have signed their own pact with Mephistopheles. Rosa's own words can shed light on this treachery. In her last piece of writing, composed four days before her death, she writes that 'any "order" that needs to be regularly maintained through bloody slaughter heads inexorably toward its historic destiny; its own demise'. And now that the reins of the counter-revolution have been pulled by Messrs Ebert and Noske, in a Faustian pact with the German bourgeoisie, to maintain their own power, lining the walls of Berlin with the blood of the proletariat, we can state that a particular kind of darkness presses all about us. On the road towards socialism, we have lost the everlasting light of Rosa Luxemburg much too early. I can agree with Goethe: 'In my heart, too, all now is night.' Yet, the origins of the power of German social democracy have always been drawn from the strength of the German working class. Within this dark shroud that presently befalls Ebert, Noske, and their parliamentary lackeys, the 'destiny' that awaits this betrayal of the workers can only be brought about by the workers themselves. The castle that German social democracy has built in allegiance with the bourgeoisie stands on sand. It is up to the workers to make it fall.

AS IT WAS, I HAVE A PROBLEM WITH AS IT WAS*

Should objects fall apart or should man?' [1]

IT'S A HAZY MORNING OUTSIDE this hotel window, there's a bright sprawling cityscape, nearly all of it low-rise, the horizon is easily within this city's reach. In the immediate foreground, down below, is an open clearing, a rocky terrain with some low trees and bushes. At first sight, this scrubland doesn't hold much promise, yet looking again, its register is different. assumptions are deceiving, expectation can be blinding.

Nothing has changed in the room, focussing back on the laptop screen on a few opened images. I pulled them off a newspaper's website from an interest piece about an unusual discovery made in the house of a recently deceased man. There's one particular image, an oddly compelling close-up, showing only a detail of a few runs of a carpeted staircase, a non-domestic object sits on each step, the scene is bland.

It's not nothing, but I'm not noticing the near proximities... beyond the screen and outside the window. An opaque veil runs across this glass wall, softening the outside. I'm sitting so close to it, I can see its weave shimmer. A little detached, I'm pulled in and out of the room, chilly air hums, warm air hangs, back and forth...

From this fifth floor, there's a good vantage on the perimeter wall below, keeping the scrubland at bay from the hotel interior. Just beyond this wall, to the right, lounging under some low trees, are long-horned cows, a few dusty black forms. Among them stand two white storks, motionless. A digression of matter...

Going back to this image on the screen, I'm thinking about all the choices made by that newspaper's staff... selecting it, framing it such... what do they want me to see? They have an angle, I see interior, mid-tones, I see carpet, metal, and cardboard.

This is not nothing, it is something.

It's everything, and for this deceased man it was all over the

place, he lived among something loved, spent a life time sharing his domestic space with cold bodywork, amid the expected furnishings, albeit fragmented, displaced inside. Nevertheless an intact object, not diminished, more omnipresent.

There's definitely something
the dilemma... where to point the camera, the press photographer needs to know, evoke an abstract, make a connection. It's a shame none of the fragments or components are photogenic, and that interior doesn't give good light and shade.

The recent death of Stuart W. turned up something that interested the press, an object he owned, and more pertinent was how he'd *kept it*. OK, he lived alone, and sure, that adds a little colour, much easier then to devalue and sentimentalise.

So many pieces.
Naturally the newspaper goes with the *outsider's* perspective, who's an expert... their protagonist. From outside in, he was called... to come and see. Expertise is reassuring (in any field... but we don't need to go into specifics just yet) We're told, on answering a phone call... our expert drove straight over to see what could be of interest, in the house that belonged to a formerly living Stuart Wallis.

On arrival, our expert goes inside... knowing nothing at this stage, he moves through the rooms, lower floor, and then upstairs, space after space... he sees clutter, an unusual massing, he notices an array of fragments, gradually understands that there is something of scale in here, albeit... in bits and pieces. More awareness comes... a disorder that speaks of order, this is not nothing. Something is here, set out and stored away, some parts are positioned all the way up the stairs and down the corridors, others on shelves, and around the edges of rooms. We have an archive, at odds with the domestic habituals.

Other smaller components are stored in containers and neatly labelled; some were submerged in oil, in glass jars, placed into cupboards in tight rows.

Nothing was obvious, on that first encounter.
The combined combination of all the parts... was his and it was not nothing,

(as it was) an automobile... the article tells us, was *really* something. In that suspended domestic state. *Things usually fall apart, if you don't look after them,* but not in this case, nothing was left to fall. This apartness was looked after, carefully maintained

As it was, I have a problem with as it was. And it's clear the narrative wants us to dwell on, wants to take us back to 1928, when Stuart acquired his complete fully functioning desirable machine. It rolled off the line, a brand new Bentley... first formulated into a unitary entity in 1928. Black and beautiful, one of a few, how highly this should be held, coveted and caressed, and more, no? A black and white photograph accompanies the article, shows a happy young woman sitting in the driver's seat of the car, smiling and gazing straight into the lens at you. The caption reads: 'Unknown woman'. All the trappings, the pieces are being nicely lined up.

There came a point, a decade on, when he could no longer afford the fuel so his vehicle became stationary, outside the house. Then within the space of two years, he could no longer afford the tax needed to park it out there on the street.

Stuart relocated this machine, he took it indoors, piece by piece, separated them, and moved everything into his domestic interior.

He got to keep it, to live with it... and keep it without show. There is a different type of knowledge, when everything is held and nothing seems to change. But, of course *you do*, as he did... as moving around that interior, gradually less and less shifts, until everything settles, *he and his inventory.*

OK so the narrative wants to pull us away from *what it became,* fast forward past all the decades this automobile existed in this state (suspended, in storage, diminished no) fifty years... is a long time, and it's nothing. Ignore the reveal photograph, the immaculate re-conception; gleaming Bentley in a glowing white void, reassembled and coaxed.

Their cohabitation, that relationship, together, is some interiority. A simple digression of matter, exterior and interior. If it is simple, then that's the hardest thing to understand, for filtering through a newspaper titbit.

Here was something else: a displaced set of relations, and a kind of love, more than mere tolerance, but did he love it, later on, after... maybe that's the old sentimental spin, we like or need to project onto others, easily done when they are gone. This phase of redistribution, of interior fragmentation, is a quiet mutual acceptance, where nothing changes. Not like this... move onto the now, to the reassembling reveal.

No, too soon and too easy. Dwell, let's sit still amid that arrangement, let's listen, let's navigate, let's sleep on it, again and again and again.

From velocity and agility, the plight of a machine is... like us, settled, atomised and in proximity settled... 'when a post-nomadic humanity won over the threatening fluidity of the real, this will to permanence invented the city (*Stadt*) and indeed the home (*Bleibe*), an abode that will remain (*bleiben*) the same and in the same place over time'.[2]

Did this end well? It began better, but what does any of that matter, it is the decades in between, a sheer unravelled state of co-habitation, the promise that parts held for a man, who once knew what the totality was capable of. His younger self he may have no interest in revisiting, or maybe that machine is tied up in someone else, tied to memories of another, or others. Then again, everything goes. And what, then, are we holding together?

Circling over the scrub land is a kite, a type of eagle, idly gliding in loose figures of eight. Effortless economy, all movement below is keenly observed. Can she see me in here, this interior, this screen, even this image? You expect without sentiment. Out there she has an implicit understanding that sunlight has weight.

* From a hotel room in Hyderabad, India, 19 November 2018.

NOTES

1. Carl Einstein, George Braque [typescript, early 1930s] in W3-251-516; 348,350), referred to in Sebastian Zeidler, *Form and Revolt, Carl Einstein and the Ground of Modern Art*, Ithaca, NY: Cornell University Press, p. 161: 'Tradition accumulates in the object. In it the immediate is shifted away and squashed. The task of revolution: De-objectification (*entdinglichung*), destruction of the object for the sake of saving man. Man is tired of describing objects; he tries to assert utopia without concern for the objects and people objectified through ownership. Objects, a means of passive thought, mnemotechnical snags [...] Should objects fall apart or should man?'

2. Carl Einstein, '*Revolution durchbricht Geschiche und Uberlieferung*', in Hermann Haarmann and Klaus Siebenhaar (eds), *Carl Einstein; Werke*, vol. 4, *Texte aus dem Nachlaß*, Berlin: Fannei & Walz, 1992, p. 146.

ORATING THIS ORATION

FILTHY DOGS. THINK THEY ENDED IT. Red. Like fuck. Like hell. How not to be pugnacious. Why the fuck not. Two forces. We know what side we're on. Religion rammed down throats. Save some. Privilege for others. What a pleasure that must be. Balls the size of balls. Different spin on giving no fucks. Drunk while at this. Fucking girl god. No point in lament. Vulgarity in nostalgia. Must not go there. Live. Love. Die. Not dead. No fucking way. We're still in. Worship. Stories revered. Tricky for a she. That much power. Wielding influence. Like Christ. No miracles. Crowds gathering. For what. A good life. Not one needed to die. Not her. Pressed flowers. Who really knows. No time to idle. Can not out think a thinker. Don't trust the books. Romanticising her godliness. Solitude couldn't break. Remembering her feline. In all that was good and wholey. No poetry in death. Just death. No life in death. Just death. Lights fucking out. Forget about it. Not for some of us. That particular god dess will never decease. How to be remembered. Like one gives a fuck much. Hopeless endless pile of stinking shit. Rotting in water. Who the fuck does that. Don't want to fucking know. Don't want to write. Want to wail. Wail and groan. Animal. Base. No comprehension. Had to do it. For the sake of the commune. Solidarity means fuck all when you're alone. Comrades gone. Family forgotten. Come in. Go out. Solo. Nice-looking word that. What to be her. Seat at the table. No. Not fucking leaning. In. She saw it that particular form of indoctrination cumming. Not turning. Grave. Sisters had her back. For what. This horror show we return to. For what. Hard life. For what. Romanticising her won't do. Worship the fuck out of her. Idiots. So they could continue to kill her. Babies none. Lovers many apparently. Broken body. Fear. Her ideology. Terrifying the fuck out of them. On ideological rampage. Fantasy in the damage it could have caused. Never give up. Least we forget. They say. You're forgetting every day fool. There is no comfort in ignorance. Only unforgivable ignorance in ignorance. Clumsy that. Fits. Brave. Smart beyond. Gorgeous. Good and Right. Red.

A LOVE LETTER TO ANDRE LANCASTER

UNDER THE ARTIFICIAL BUT HIGHLY industrialised canopy that was the D-train running above ground directly over our heads, we stood outside for our first heart-to-heart conversation. It was summer in New York City, distinct in humidity and activity from summers anywhere else in the world, and the workshop process for your Black queer theater group with its five playwrights under fellowship had begun. Monumental was the fact that we were Black writers commissioned for actual pay, read: real money; miraculous describes the dream realised and its impact on our creative lives well into our queer futures; 'divinely powerful' is the phrase that comes to mind whenever I think of you, a young gay Black man whose ministry meant creating theater for queer Black playwrights when it wasn't a thing, wasn't trendy or an identity-marker to distinguish oneself at parties among the liberal elite or leftist intelligentsia who tend to populate if not dominate theater circles in America's artistic landscape. But on that sweltering hotly humid summer afternoon in the city we stood on that sidewalk like true transplants, non-New Yorkers hands-in-pocket unworried about the future, our relevance, egos or death through denial and Black artistic erasure thanks to White Supremacy, or even that we desperately craved two tall glasses of ice water plus a pair of fold-out beach chairs to shoot-the-shit authentically. Heart-to-heart was our conversation that went something like this:

'What you're writing is bullshit.'
'Bullshit?!'
'Is there something I should know? What's wrong?'
'Gimme a sec to catch my breath. I'm still stuck on "bullshit."'

Then you quickly followed up with, 'This is a safe space. Affirming. Here is where you can be soooo free you soar. I, we are your anchor, your queer family, can't you see that? Don't you feel

it in your bones?; The initial tenacity and accompanying paranoia that comes with a new ministry often masks the deep love and fragility of its first founders. I knew then but not like I know now, many years later, that when a Black gay man is pregnant with a vision, when he finally gives birth, sees his baby take its first step, nurturing that dream to maturity instantly makes him a marked man, a target destined to die multiple deaths in one lifetime. For support, for spiritual food, to make sure his baby survives this sick, toxic, homophobic, racist world, he must hold the vision tightly to his bosom, for it is himself he is holding, himself he gently cradles and rocks to sweet safety, himself he is raising up from the deaths that mark his vision-dream-child wherever they are, whoever they become, no matter what they manage or are allowed to attain.

Heart-to-heart conversations among queer folks of color are staple to our diet, not just for purposes of survival that craft heart-shaped solid bedrock into beautiful Black being, but because Loving looks like coming together. You know that moment when witnessing the arching neck on its way back before that burst of laughter painting a sunshine only heartstrings hum to warm Black queerness. Or that dramatic, giant step into the limelight at a party to prove your hairstyle, hot plate, and outfit mean so much more than style, transcend current cultural politics, make mockery of mainstream etiquette. Pockets of conversations that drop truths to soothe you right after your partner now ex deadnamed you during otherwise hot sex, truths whispered centuries ago among our Queer Ancestors when they gathered together for food, dance, talk, touchy-touchy during their tribal meet-n-greet. So when you told me, Write whatever you want, you were giving me permission to reclaim my Black queerness as foundational fabulousness; you were giving me permission—scratch thatmandating me to live fully free in my beautiful Black body, manifesting the miracle of my queer intelligence, uplifting my soul on and off the page which, at that time and even now, is a miracle. Like you Andre. Loving is Being is what you were telling me, Loving is Being.

Being Black queerness is nothing short of miraculous, proof? I know Black queers who've walked clear across continents to free their dying lover from homophobic hospitals into their trusted arms, ensuring that final breath was spent together in dignity. I know Black queers forced to renounce religion to reclaim themselves divine. I know gay men who face emotional isolation for standing tall and unwavering in their complex queer truth. Kicked out of their homes; denied medical treatment; humiliated by a sick healthcare system because they remain boldly Black while trans-identified; sexually and verbally and physically abused in shelters; denied passports; violently assaulted at the border. Black trans femmes beaten on the streets by cops then wrongfully convicted as whores, not sex workers, in courts with transphobic laws, sent straight to male prisons because they proudly identify as women with penises. I know Black queers institutionalised and medicated for mental illnesses that would not exist if they denied their existence, if they agreed to self-identify as cis and straight instead (of trans). Black queers pronounced demonic by a loving Jesus, their suicidal screams unheard for so long they set up a toll-free lifeline to stem the queer bloodshed, weave magical unicorns and rainbow flags from generational abuse and trauma. Elders, queer survivors press their ears to the telephone receiver, listening to queer family cry as only the oppressed can. For one pure moment of desire, Black queers whose resistance and resilience is each other because this world, with its anti-queer culture, wishes us nothing but death. Loving is Being.

You disappeared, dropped out of the scene. There were rumors. Everybody knew. They said they didn't but the truth is we all did. You moved to a cheap dump, rats with roaches, recently released convicted criminals for neighbors. By then your vision, the theater group for Black queers was dead. Lack of funding, plus some 'established' theatre institution 'awarded' yet another white creative large sums of grant money for stealing your idea, killing your vision-child. You moved twice in three weeks. Whispering began, something about an addiction, maybe

meth, possibly HIV-positive plus backsliding after rehab for the umpteenth time but during this intervention, this time you swore you would conquer your demons, kick the curse to the curb for once and for all. Loyal friends kept up the faith, urging us to go visit, never mind the stench, that you smelled like fresh shit mixed with stale urine and lived inside a tiny coat closet. Ex-lovers shook their head, propped their coat collars upright as shield against winter winds, walking speedily away, swallowed by the boom, blast and brilliance that is New York City. That same night you took a hit. Then the Junky in Room 226 told the Junky in Room 225 there's a strange smell in 224. Three days later, when the cops broke down your door they found you in bed with your most faithful lover, a meth pipe nestled sweetly between the sheets next to your dead body.

Being Andre meant carrying the burden of other people's fucked upness. Because racism. Because homophobia, queerphobia, transphobia. Because the Black Family is under siege. Because you were so ahead of your time you gifted everyone else with a future. Because queer masculinity coupled with Black Brilliance is butchered in this toxic society. Because Black Love is as criminal as poverty is shameful in a hyper-capitalist shithole democratic dumping ground of a country like America. Because there is no such thing as celebrated, safe space for queers-of-color. Because we are forced to use English, a colonial language, to decolonize our dreams. And still, despite what stood between you and insanity, you claimed your identity, birthing new realities to transcend bigoted circumstances. Fabulousness? you? yes of course. You dreamed big, dreamed brave, dreamed strong, dreamed bountifully beautiful of queer pride.

How many times did they rape you, shame you, ridicule you into submission until you disappeared? When was the first time you feared for your life? When did you know there's a difference between being alive and queerness? The first time the community failed you, what did you tell yourself to get up the next morning? When we failed you again, you got up yes, but was your pain floored or could you carry it past the door into the outside world?

At what point did you stop performing to let the mask slip? They killed you after that, I know, but how? Did you die when they shouted 'faggot' or the word 'art'? TV taught me how to love my queer body by hating my Blackness; and you? How crazy is too crazy if you've never seen yourself? Never ever whole, never ever full, never ever beautiful, never ever man enough or woman enough or Black enough or gay enough or queer enough, never ever human, never ever free. When the mirror is your rapist and society can't stand you long enough to look, you must obsessively wonder if that's why the future screams back invisible. That breath between survival, what broke you Brother? What made it impossible to hide your pain? Beloved?

Now, transition completed, you are among Queer Ancestors whose sole purpose is the exaltation of life divine as love supreme. Consciousness meeting consciousness, you have no material body. Think: how radical is that? For a queer Black gay man to finally, finally be free of his body, released from gender-based stigma, unbound by racial constructs within divine love that radiates your core being. At the inner sanctum of which is your vision of a theatre group for Black queers, still pure, still enduring, resurrected, now alive among your Ancestors who live to honor their own. Finally, in death you have attained what life viciously robbed from you; a loving home, safe space to celebrate the fullness of YOU.

Forgive me for running away when you stood tall and strong to claim me. In the name of our Ancestors, please forgive me for not honoring the strength and power of your vulnerability. I turned my head to stab you invisible, making me unworthy of being your brother, of claiming myself family, African, queer, a member of the tribe. But today I surrender to my grief by uplifting you who were so much better than this world. With love everlasting, I say your name as prayer eternal: Andre Alexander Lancaster.

I love you,

Nick Hadikwa Mwaluko

AFTERWORD

Mourning, unlike grief, is a scripted ritual for a circle of intimates who gather together (usually in all black) as testament in honor of life passed. Grief, by contrast, is neither scripted nor collective in expression, perhaps because its invisible twin is love. Like love, grief defies social scripts; like love, grief celebrates chaos, transformation, upholds power, vulnerability, helplessness, surrender. This piece not only examines loss of life but looks at the multiplicity of deaths in a single lifetime the moment one identifies as black and queer. The intimate circle, also a tribe of queers-of-color, anticipate systemic (#cistemic) death by erasure, silencing, racism, patriarchy, shaming, stigma, self-sabotage, addiction, escapism, lethal doubt, queerphobia, and, because of all this and more, we are numbed, read: complicit by inclusion. As the forces of White Supremacy feast on Black bodies, queerness is the only cure, but only if fear does not limit its expression. I grieve Andre because I was afraid to love my Black brother queerly, read: fully, truly. NHM

WAKE, ROSA

WAKE, ROSA! ORDER STILL PREVAILS in Berlin. We have a wake for Rosa, to wake Rosa. But Rosa is dead, and we contemplate the image of our own death in the image of Rosa's death. Eternity, what a fraud! Images and images and images. Tautology and repetition are the powers of death, antagonistic to our living. Dead forms as well. The still life is dead nature (as is said in French and Italian), life stilled to the point at which it is an image of death. Today, cubism has killed reality and Western art is dead. Rosa is dead. We live in the midst of death and we are the slaves of dead forms. Our society is as funerary as the Ancient Egyptians: our factories are the dead monuments of living labour, the sacrifice of proletarian bodies on the altar of capital to the capitalist Pharaohs. Every commodity is a death mask, every moment a moment frozen into the abstract forms of value. Rosa tried to wake us from death, tried to awaken us to the living powers of the masses, but we remain dead. Order prevails in Berlin. Order prevails in art. The capitalist order prevails.

The streets were both the subject and the object of revolt for Rosa. The streets crossed that divide, they acted as duration, as flux, as event, as process, as the form of life which the masses inhabited. The streets did not kill Rosa, Max Weber! Rosa was the streets and the streets were Rosa. Rosa became one with the streets, woke the streets to their capacities, and joined with the streets to the point of dying with the streets. Reaction killed the streets in action and reaction killed Rosa. Failed soldiers, fresh from defeat, these fragments of mobile space who imagined themselves as heroes, revenged themselves on the masses and drowned the streets in blood—as they had done in 1871 and as they will do again. These toy soldiers played a giant *Kriegsspiel* in Berlin, Munich, and across Germany, puppets in the hands of Ebert. The game was played to the end. It began with a provocation, the provocation of death and the world of things

against life and the masses. It was a game that Rosa joined with lucidity. Rosa knew the lesson would be defeat from the start of the game. This game was no circus act or cabaret. There should be no songs for Rosa, but decadence will follow. We will sing maudlin songs for Rosa, rather than live as Rosa did. We will wallow in decadence and then profess surprise when reaction stalks us again. While we obsess over death, we will fail to see the death masks that will come to crush us.

The streets were filled with monsters and Berlin was a snowy and nocturnal hell that winter. The capitalists and their pawns were a host of devils and demons that stalked the streets for their prey. They tortured, tormented, and celebrated orgies of suffering. The revolt tried to give form to these monsters and demons, to find enemies amidst the snow and night and fog of war. These enemies coalesced and then disappeared; they will form again. Under the starry sky the cults of the monstrous, the cults of starry wisdom, formed before the eyes of the workers. They called down death and they will call down the end of the world. Rosa knew. Without revolution, they will come for us all eventually. Sooner for some, but eventually for all who oppose them. Hell will feed on the bodies and souls of the workers until it is glutted. The carnival of reaction I know: the collective frenzy of breaking heads, of hanging, of torture, of the age of messiahs. I have read Karl May, my namesake, and know, like a reader to come, how things will end: another set of myths, another set of dreams, a colonial frontier that will extend across the planet, the mirror smashed.

Rosa knew her fate. Already Rosa predicted a bullet of the counter-revolution that lurks on all sides would send her to the other world. I expect also to die in a similar fashion. Although, like Rosa, not even the mercy of the bullet is reserved for all. For some also degradation, torture, public shame, and to be thrown like trash into a canal or a ditch. To die like a dog. Death, however, is a prejudice and we need a creative dying that resists the abstract logic of death, leaps beyond death, dissolves the subject, and produces new ruptures and new forms. Rosa knew

she was a part of this creative movement, a part of the masses that would sweep away the dead forms. She even went willingly as a sacrifice to the revolution. To repair and sustain the moment of revolt, after all she could have fled many times. She decided to die with and for the revolution as a sacrifice that was part of a movement of life. She is a martyr to a revolution that has only stalled in Berlin, which will return. Defeat was a lesson to be learned.

Wake Rosa! Already legends are told in the working-class neighbourhoods of Berlin that Rosa is not dead. A body recovered so long after being cast into a canal leaves room for doubt amongst the most rationalist of comrades. Those legends say that Rosa was not killed, but escaped, as could have happened, and that at the right time will return again to lead the fighters to victory. Are not these legends truer than our disenchanted mourning? Do not they serve the struggles of the proletariat better than morbid reflections on necessary failure and the need for 'rational' strategy? If Rosa lives for the working class it is because she lives as a sacrifice to them, a resurrection, so an all-too Christian schema, but then one deformed and reformed into a revolutionary schema. If Rose wakes, she will awake at the right moment to lead the fighters to victory. She hides from a reaction that will not cease to darken the future, but she does not flee in terror. This is no sign of weakness, but of reserve and patience. Wake, Rosa!

THE GRAVE
for three voices

I

graveserious

das Grab boxedin

ernst buryburied

eingepackt bittercold

begraben bitter cold

 I want to burden the

bitterkalt conscience of the affluent with all the suffering

 please all the hidden bitter tears

bitter vibrant

Bitte carnation

beshwingt cold

Nelke grief

kalt tears

Trauer gatherassemble

Tränen

 I want to be specific

versammeln

 I want to organise

II

something
 graveserious
 · next

 das Grab a bit of pulsating cut out
 boxedin
 I want a thousand veins

 I want to ernst the lumpen proletariat
 buryburied
 labour

 eingepackt break the camel
 bittercold
 I want us to feed each other

let me begraben
 bitter cold
 burden burden

 bitterkalt affluent suffering
 please
 hidden bitter

cover your grave bitter in red carnations
 vibrant

 I want to Bitte systemise
 carnation
 I want you on

 beshwingt cold assemble me
factory workshop mine

 Nelke
 grief
 office space

 classroom kalt driver's car
 tears

 I want to span Trauer
 gatherassemble
 those voices scream

scream Tränen rough trade
 to be specific

 versammeln

 to organise

116

III

I want something that is no longer necessary
 graveserious
 what next?

 das Grab see a bit of pulsating cannot be cut out
 boxedin
 I want revolution of a thousand veins

 I want to ernst penetrate the stratum of the lumpen proletariat
 buryburied
 labour of

 eingepackt I want to break the camel's back
 bittercold
 I want us to feed each other 's children

let me tell you my begraben premonition
 bitter cold
 to burden burden I want to burden the

 bitterkalt conscience of the affluent with all the suffering
 please
 all the hidden bitter tears

cover your grave bitter in red carnations
 vibrant
 & recognise your buttonhole flower

 I want to Bitte systemise hard facts
 carnation
 I want you to use your imagination

 beshwingt & your mind to assemble me
 cold
factory workshop mine foundry cinema box

 office utilities Nelke cupboard shop floor building site
 grief
 field and barn rented room shared office space

 classroom kalt industrial kitchen back cabin driver's car
 tears

I want to span Trauer time and space
 gatherassemble
 make a portal for those voices a space to come screamaway the weight

 the weight Tränen of death through trade

 I want to be specific

 versammeln

 I want to organise

59275

The squeaky laughter
Of a capricious barbarism
Drowned out
By the fruitful bubbling
Of your resistance

ROSA WAS OUR FUTURE, AND NOW WE ARE HERE

OUR YEAR BEGAN IN JANUARY, a fraught month.
In Poland Bourgeois Princes called themselves National
Democrats, and even German Farmers were socialists!
We started publishing about the real lives of forms elsewhere in
bloody earnest, picture portfolios for every one! each issue eight
pages thick for 60 pfennig.
Everyone saw Spartakus at work!
The fair chorus of Southerners sang like a gramophone in a
bordello where the girls had killed their pimps and decorated in
the Spanish style emphasising intricate Gothic forms in the red
spray of their bosses' blood.
The worst were full of Europe, and the mediocre became
murderers of the best.
When they killed Karl and Rosa, I felt like that fellow
sandwiched between a businessman and a woman's leg in a
painting by a friend.
Our time struggle was devoid of any spontaneity.
I was frozen in a cold house where they are careful never to let
the clients cross paths.
Every form that emerges is an insurrection,
and every rebellion takes its form

I was arrested on the same day and escaped to hide in your
houses.
On the sabbath, I emptied the ashes from the furnace in the
basement at night.
Some of us will want to leave eventually but one
of you told me that in Amerika, THEY tell the
proletariat what to want, and perhaps we are better
off staying where THEY tell us what to do.

If you remember me, remember that I fought, and that Rosa
showed us how.

Someday, someone will think themselves clever for describing corpses as 'time-based site-nonspecific Installation', but our mourning will be remembered more for its organised necromancy.
Every form that comes into negates a form from elsewhere.

Rosa Red Rosa will find other ways to make it new long after we are gone, and these are not her real remains, which will have been what returns to this crypt for the first time when the earth is exhausted from the end of accumulation, like a distress signal on sinking ship in a storm that only gets more severe.

DARSTELLUNG, LUX
NOTES TOWARD A SUPREME FRICTION

RED ROSA, YOU TOLD THE POOR the truth with such persistence, and in the process generated a cubist Marxism. First the social democrats who hated your plan for a general strike and no more inter-imperialist bourgeois war, then the fascists, those pop-up architects of expanded devalorisation, tried to kill you.

But like cubist Marxism, you could not be killed—and also like cubist Marxism, you cannot be completed, only completely abandoned.

To be clear: your theory tells us that primitive accumulation— the capitalist imperative of separating people and things (whether that is subway systems or ecosystems) from their means of reproduction—is not just the first chapter of capital, written in letters of blood and fire, it is also the continuing story of the disaster as a whole, a history that is still being incised into our collective skin.

Resisting this, a cubist Marxism might be perceptible and a Marxist cubism possible—a Marxoid cubistics of the economic which sees in historical cultural forms the precise signature of their conditions of social reproduction. More specifically, by positing the identity of your theory and cubist art works, we can better squint at the lineaments of the crisis as it unfolds like a garment against us, our expansive deserts.

It is possible to begin to outline what this two-way street, from cubism to Marxism and an expanded Marxism to cubism, would look like in a continuous language fitted to the occasion.

It is possible to hymn this street in the shape of an elegy or eulogy to Rosa, the engineer who cut it through me, with the help of Picasso and Braque, but time is short and so is money, we give voice beside the grave, and as we speak the scale and scope of the grave is growing. So we must be brief and paratactic––

To remember Rosa:

I will cite everything I have yet to write about Picasso that reminds me of Luxemburg's great but too little read and understood, *The Accumulation of Capital*. I will set it down as if it were a picture issuing from *the beyond of an immediate immanence*. I do this because this hypothesis is a) true and b) as the hastily assembled figment of a fictitious-capital-backed Author with a full-time job and no time to think or write, I, too, am a paper claim. I am a risky fiction that leverages its assets as best it can though I, too, may see my stock collapse in the coming global rout.

SO: Cubism is not just an aesthetic option among others, it is one of our only possible techniques, since like the riots to come it is no method at all.

All that was previously fixed—objects, principles of conservation, and mnemonic conventions—is overwhelmed.

Construction is founded on a tectonic hallucination.

Capitalism has too many people.

People have too many capitalism.

The premise of any immediate construction is nothingness.

Objects represent, rather, an obstacle to hallucinatory figuration, because they divide psychological processes into two realities, and destroy concentration.

Equally having a real economy and a false one is a total joke, fit only for the far right.

Rosa refused to divide production and reproduction, to destroy our concentration on total capital by making it too manageable, too easily figured. There is no equation for total social reproduction, for total capital, and capital is an open-ended system with no necessary breakdown crisis built-in.

As in cubism the object is strictly a result that arrives only at the end of the process and includes the viewer and reader of the work. As in cubism, accumulation arrives like the purloined letter always and only at its destination, the process of valorisation is open-ended, includes the one who would write it down, and arrives only by way of the detour of the empirical real.

Capital cannot be put down on paper in black and white, though it is unthinkable without its vast accumulation of paper claims. Put it another way, we cannot make do with a volume 1

Capital account of capitalism; we must include the whole three volumes, plus the parts unfinished, just to begin to approximate to what was taking place when, like Tristram Shandy, you set out to make up your accounts in the first place.

You must include phantasmagoria and the world from which it bleeds, the fictitious claims that insist on referring to reality that really can go on collapsing without crushing any domination.

Representation is not a neutral or scientific affair—only a revolutionary can see any future whatsoever, so Rosa showed us communism or barbarism not simply—*this doesn't look good*, or: *people are bad, let's throw them in the pit.*

Darstellung [presentation] demands a writing down of what is overvalued while noting everything that sustains those values for as long as they are sustainable at all.

Today we see Reaction wipe out those who have got their number; we also see how representation takes its revenge on the attempt to picture a totality that exceeds picturing. Your plan for a general riot horrified the right and was too big for the picture of the left.

Yet this was clearer in your drier book than in the ones most often discussed, or even read. We have to go to the outside in your œuvre to recover you today, to make sure that you begin living among us, not just being rolled out as the usual undead Trotsky-endorsed zombie or democratic idol or another recycled cipher saying free speech is for those who can still bring themselves to write for Zero Books, but as a theorist and fighter of urgent interest in our current struggle.

From *the beyond of an immediate immanence*—from the excluding-in of the outside and the including-out of the within, this dialectic of economic involution, this spatio-temporal formula of permanent and developing primitive accumulation— is the figure of your legacy.

You saw the reality of capital in the 'developed' world, and of culture—its preconditions, its posited presuppositions. We must see your writing in our world, the interaction of the fictitious claims and the looting that they license.

Recall Duchamp's readymade and the vast expansion of the field of artistic action it entails, recall the reduction of his innovation to a mere machine of nomination: something similar can be seen in the non-reproductive logic of a financialised art or economy, a culture of unlimited iteration without expanded reproduction. Writing at the same moment you blasted out *The Accumulation of Capital*, Picasso and Braque were working through the implications of integrating the outside into western art— exploring the *dis*integrations of capital, you might say. You each in different ways took note of the terms of the transaction between France and Africa.

You extended Marx beyond Europe to analyse Europe's necessary implication in its beyond: the beyond of the closed system of reproduction in Volume 1 of *Capital*, of the equations of social reproduction in Volume 2, of the *ailleur*s in the *ici*. The process of cultural inscription, the writing down of a cultural form and its translation into a new modernist practice, also arrives after the non-equivalent exchanges (the theft of labour-power and land) have taken place.

One can only take the value of African art after French banks and financiers have established the financial machinery by which Egypt is looted; when the reproduction of the labour-power of the fellaheen secured at a cost of $0, appears as a free gift to the European capitalists included with every bail of cotton they produce.

Phantasmagoria is not only a matter of non-equivalence in the form of equivalence. It is also, through the powers of debt and credit, the omnipresence of the supplement, of non-equivalence or difference *per se*. What will be valorised in the register of culture is always already valorised for capital, but through a supplementary fetishism which determines whether this supplement is a plus or a minus, lack or excess in terms of social reproduction.

Who is enriched by the transaction between French and African, in France and Africa, in art and culture, becomes the decisive question. Who will be reproduced and who contracted, who repeated and who replaced? It's almost a pictorial question—

who gets fed, who counts—but only if one sees that the material reproduction is as important as the semiotic. (Mr Ranciere, you were quite wrong about the philosopher and his poor: the philosopher turned out to be right, as Rosa predicted by drawing out the flaws in his schema). The form of social wealth is what must be over-turned. Cubist Marxism already says as much, marxoid cubisms reverberate to this in their wordless forms, in their resistance to realist representation—from the beyond of an immediate immanence. In plain terms, when there's no more room in capitalism, the (freshly murdered) dead will walk the earth.

Rosa is gone but her time is yet to come. When the left was refining the theory of the capitalist development state dressed up as a socialist utopia, Rosa persistently showed us the truth about the paper claims of capitalists and socialists alike: *what is at stake is not reproducing* [Abbilden] *but forming* [Bilden].

We must make a cubist marxism in theory and in practice. Rosa Luxemburg's 'open system' model of capital assumes the ultimate unrepresentabilty of social reproduction, and yet struggles to present the full balance sheet of disaster, the monstrous, the fascinating, and the tragic. Perhaps also, in the rioting, we can make out intimations of the comic—of the gluttonous, vengeful, and proud. Cubism as isomorphic with Luxemburg's depiction of a system in which the trade in non-equivalents is not accidental to the reign of equivalence, implies disasters for capital as well as disasters of war. Can we imagine a utopia of non-reproduction? A form that ends if not in love then in something other than expanded death?

I have long known that the thing one calls 'cubism' goes far beyond painting... Cubism is tenable only if one creates equivalents in the mind.

Say art and economy are equivalent, forget your base and superstructure (nineteenth-century pictorial devices) because every detail of a society is part of the totality like the details in a cubist painting, a rash of *puncta* left when all *studia* are deflated. Neither can be made to add up to anything you could count.

Alain Badiou reminds us of the principle of uncertainty, but the certainty of the unprincipled is what we rediscover in

Luxemburg. Not the familiar relativism, perspectivism unbound, of the bourgeois accountant but a new principle of synthesis, at once disjunctive and dialectical, lawful and ragged at the edges.

The cubist idea of the object as result of figuration, rather than prexisting it, parallels Luxemburg's conception of the commodity as result of exchange. Luxemburg assumes the whole process of production and (non-)reproduction as pertinent for capital accumulation, not to mention the human lives caught up within it. Value is created retroactively through realisation of the commodity's value in exchange, and—*contra* those who repeat fragments from Volume I of *Capital* like a mantra—its quantity is not arrived at absolutely independently of the commodity's quality (its use value), nor of its destiny—as means of production or means of consumption; of productive or unproductive consumption. There is a real difference between an economy of prisons and an economy of factories, mass production of guns or of butter. If an exchange value loses its use value, both may be destroyed. And if capital turns to mass production of non-reproductive values, this tells us something about its innermost contradictions, its historical limits. Total capital is the product of the commodity's genesis in the entire chain of valorisation, from Egyptian workers' 'free inputs' of unpaid for labour-power to the chronologically and logically prior creation of the French bank loans that would pry this out of them along with each bail of cotton.

And so it continues, all the way down to the arrival of commodities—*via* ports occupied or unoccupied – at logistics hubs in the Parisian or Lyonnaise *banlieue*s. Commodities arriving for purchase and consumption by the French consumer (whether Dept I or II, productive or unproductive, cop, *gilet jaune*, or industrial labourer). We arrive at the process whereby Things arrive, and indeed gain a sense of how they can be blocked, caused to arrive very differently, or indeed to not arrive at all. Who benefits and who loses in this crisis of circulation is the decisive question.

Rosa's cubism comprises war and devalorisation–the pitiless destruction of life, the rending of worlds, the ripping open

of the interior of all things. But Rosa also taught us to see the ghostly outline of a world beyond expanded disaster, beyond this immediate immanence, where the writing down performed by capital is echoed by workers rioting to set the price of *everything* to zero, rendering a non-equivalence that no longer reproduces the identities necessary for exchange, a non-reproduction without reserve.

Rosa taught the poor the truth that accumulation, and revolution, are not automatic; but her account of social reproduction implies that collective automatism is capable of writing both far worse and far better than the total social literature, the total social picturing of all previous societies, better perhaps than we can collectively plan (hence, also, her resistance to the *soi-disant* People's representatives in their attempts to take leadership of the revolution from the *people* who had up to that point lead it themselves). *Darstellung* means there is no direct line to representation, whether electoral or aesthetic. Whether we would produce a new picture or reproduce the world *we must not reproduce but form.*

ANTI-SENTIMENTAL LOVE

I HEARD ANNE BOYER GIVE a work-in-progress essay-poetry-reading in the Literature department at the University of Amsterdam recently, and she talked about the anti-aesthetic poem. How non-sentimental instances of poetry deprived of false glamour were kind of where we should be striving for if we want to refuse 'giving the miserable the false shape of the inevitable'. And this instance of poetry could still be a way to entertain the possibility of something else, between refusal and resistance.

I don't know what Einstein said in his oration at Luxemburg's memorial. Hell, I didn't even know who Rosa Luxemburg was before I got this invitation to contribute. This invitation came as a call out of the dark from an unknown yet known place, a place we all have been to but never really visited. The place of poetry and oratory has always been there, in our mouth, in our minds, in our eyes, gazed at by the bewildered surveilling entities that haunt us, that circle us, that face us. We, if we can speak of such a we, are encircled, are against the wall, are trapped. But this trap has a kind of secret door, like in the movies when the villain or the hero presses a button on the wall or behind the bookshelf and suddenly the wall flips and turns and another opening appears. Poetry is that button, poetry is that sliding door, poetry is that revolving bookshelf, the bookshelf of history, of past and future, of openings into another world, the other world from which we speak, the other world from which we observe, the other world from which we await, patiently, the becoming real of a range of possibilities which we and others close and far have been waiting for.

I seem to fantasise that I'm drawing the necessary power from Boyer's work in the same way that Einstein might have drawn his from Luxemburg. These powerful voices, the voices of power-poets, tremble with fear and yet this trembling fearful voice is so potent, so guardiant, so funny, so comforting, so loving. Neurotically inadequate, these voices leave no trace because when you try to

recall what was said, what these poetic-superpowers said, you can't really. You only remember the tremble, the fear in their voice. Semi-aware of their own super poetic powers the tremble comes across as a coded call. Those eavesdropping cannot really detect the message, but those who await or are tuned to fear and tremble can tag along easily.

Who knows what was said on Luxemburg's grave? No-one. Does it matter? Maybe. But even without any trace of the oratory an invitation was sent, an invitation was conceived. But how? Do some of us share invitation rights, rights of invitation? But regardless of whether or not an invitation to speak was present, hair speaks where the mouth remains shut. Einstein for sure had particular hair. A crazy scientist's hair almost lending his crazy hairstyle to Luxemburg's beaten-up and buried body in his oratory. The inventor of the theory of relativity had a relatively inventive hair-style. Did they check for hair samples in the site of the oratory? Perhaps the trace of the event was left in a hair sample. Should we call all the investigative squads to return to the site of inspection to check and recheck if any hair samples were left behind? The hair that connects our scalp with the air above us. The nose hair that somehow connects our nostrils with our lungs, with our mouth, with our tongue, with our voice. Try to speak without breathing. Try to breathe through your nose without vibrating your nostril hair. In that sense hair is also an oratory of a sort. Caravaggio's *Medusa* has an open mouth and a bad snakish hair day. Shhhhh, the snake language. Sssssss. Was the oratory delivered in snake language? Should we investigate if there were any snakes around who witnessed Einstein's oration? Einstein did have rather snakish ears. Was he a reptilian? We know he was somewhat of a rootless cosmopolitan. Did his rootlessness teach him that no traces should be left behind? Did he erase any traces of the oration so that his rootlessness can prolong? So that he does not tie down his vocal cord vibrations to a certain rooted site, however temporary. Bald wig-bearer manikins of poetry when will you take off your poetry-wig?

How to talk about the phantasmic and yet remain true to an initial impulse of non-sentimentality? How to not let words carry themselves away? How to tie down voice to a site? These are not the questions behind the revolving door of poetry. Other questions are more pressing. How to keep the door revolving is slightly more important. So abracadabra your way through dear Einstein, dear Rosa. And anyway who cares about truth? Honestly, even my six-year-old cousin that I don't even have does not believe in truth anymore. Meaning is another story. And maybe through the search for meaning we might be able to dig out a hole in which to hide the phantasmic. Rosa Luxemburg's body was lying in the canal for six months. Six months! Can we even start to imagine the horrific deterioration of her body in the water?

Anti-sentimental does not mean without sentiment. The sentiment of the anti-sentimental does not allow sentiment to mask the task that is at the heart of the anti-sentimental, namely love. Love, that beaten-up body of poetry, frees itself from its emotional state and become a moral principle. Love thy neighbor, love thyself, love thy neighbour as thyself. Can you resist to love, refuse to love? Staying alive is a politics says Boyer. Is staying dead? Monroe was always attracted to older intelligent men. But this affection in the case of Einstein was purely scientific. Perhaps what we can speak of here is a scientific non-sentimental love. A love operation of a sort if you will. A theory of everything surely has to account for such a love as well. Although Monroe was the archetypal glamourous star, her icon remains an infatuation of a purely scientific nature, hence the repetitive permutations of her icon by Warhol and his gang. Another guy with funky hair.

WRITING WITH A PEN
THAT IS NOT IN YOUR HAND

THIS IS AN IMPOSSIBLE TASK in front of me. There is a different temporality to this, as we are activating anachronisms and speak from positions that no longer exist.

Knowing what will happen to us all, the murder of this brilliant red headed Polish-Jewish Communist Revolutionary, I know this loss is not the end. But the beginning.

In Alain Resnais' 1974 film *Stavisky*, Jean-Paul Belmondo plays the Jewish-Ukrainian Ponzi schemer who brought down the French establishment in the 1930s (his actions were used by the Fascists in their failed February 6, 1934 *coup d'état* attempt). In this film, it is the Trotskyist follower Michel Grandville (Jacques Spiesser) and the German refugee Erna Wolfgang (Silvia Badescu) who are of interest to us. Trotsky was just exiled from the USSR and was still looking for a way to take over the communist international. Michel and Erna discuss how Trotsky could control a party that was no longer subjected to his authority. Outside Trotsky's temporary residence in France Michel poses the question: '*Alors, Comment agir sur un instrument qui vous echappe, qui vous est adverse même?*' [How do you operate a device that escapes you, that resists you?]. Beyond the specific example of Trotsky and the Party in that specific context, this question lies at the heart of politics: how do we act with a tool that constantly escapes us, that opposes us? How do we write with a pen that is not in our hand? That is what politics does.

Where we are today, with the lack of basic political know-how, we look back at the losses, at the tragic moments of anti-revolutionary victories, from before the crushing of Spartacist resistance, and since the murder of Luxemburg and Liebknecht by the invitation of the Social Democrats. Party organisation or the general strike are not ancient questions for Lenin and Luxemburg scholars, but pertinent urgencies for us when we ask

ourselves who, if anyone at all, could the revolutionary subject be. Brecht would say 'it takes courage to admit that the good lost not because they were good, but because they were weak'.[1] Communism is the lesson that draws a line between those who only want to be right and those who also want power. Our classical antiquity, that is how Fredric Jameson refers to communism:

> The whole Marxist and Communist tradition, more or less equal in duration to Athens's golden age, is precisely that golden age of the European left. [...] And if it is objected that it would be an abomination to glamorize an era that included Stalinist executions and the starvation of millions of peasants, a reminder of the bloodiness of Greek history might also be in order— the eternal shame of Megara, let alone the no less abominable miseries of slave society as such. Greece was Sparta as much as Athens, Sicily as much as Marathon; And the Soviet Union was also the death knell of Nazism and the first sputnik, the People's Republic of China the awakening of countless millions of new historical subjects. The category of classical antiquity may not be the least productive framework in which a global left reinvents an energizing past for itself.[2]

Activating anachronisms, and with them revisiting potential histories, is what we are left with. Counting moments of plasticity, as Gershom Scholem would say, those periods that 'philosophers of history call a "plastic hour of history"', when opportunities for change presented themselves.[3] Between our structural analysis and the memory of great individuals like Rosa, we have a repertoire of gestures to work with—the oration being one.

Let us therefore think of the permanent revolution as a heritage that can still inspire us as it never really took place. When Alexander Parvus (Israel Gelfand) taught Radek and Lenin, Luxemburg and Trotsky in the ways of the permanent revolution in Marxism back in Switzerland, it was a convergence of structures and individuals that came together to generate momentum for a new world. These people did not win or lose the revolution when they were murdered or betrayed, when they failed or succeeded. They themselves were the revolution. Through organisation and charisma, analysis and practice,

they were at certain points themselves the revolution. Rosa Luxemburg lives wherever revolution is of the essence. Therefore, she must be here with us now more than ever.

NOTES

1. Bertolt Brecht, 'Writing the Truth: Five Difficulties', in Bertolt Brecht, *Galileo*, ed. by Eric Bentley, trans. by Charles Laughton, New York: Grove Press, 1966, Appendix A: pp. 131–50. The first version of this essay was a contribution to a questionnaire in the *Pariser Tageblatt*, December 12, 1934, entitled 'Poets Are to Tell the Truth'. In it Brecht proposed only three difficulties. The final version of this essay was first published in German in *Unsere Zeit* (Paris), VIII, Nos. 2/3 (April, 1935), 23–4.

2. Fredric Jameson, 'Marx and Montage', *New Left Review* 58, July–August 2009, p. 117.

3. See: David Biale, 'The Threat of Messianism: An Interview with Gershom Scholem', *The New York Review of Books*, Volume 27, Number 13, August 14, 1980.

A ROSE FOR ROSA

this is not the grave of rosa luxemburg she is not here you will
not find her neither will you find her at the memorial to rosa
luxemburg at the lichtenstein bridge or the u-bahn station rosa-
luxemburg-platz you can search the length of rosa-luxemburg-
straße in erfurt you will not find her she isn't walking down rosa-
luxemburg-straße in leipzig or rosa-luxemburg-straße in chemnitz
we need her but she is not here you can't stop looking on rosa-
luxemburg-straße in döbeln but she isn't there she's not on calle
rosa luxemburgo in gijón she's not at the centre rosa luxemburg
in béthune she isn't there and you won't find her on ulica roze
luksemburg in belgrade you can visit the rosa-luxemburg-stiftung
in munich frankfurt hamburg bremen stuttgart saarbrücken
leipzig amsterdam brussels and méxico but you won't find her
you can walk through the centro commercial rosa luxemburgo
in madrid but she isn't there and neither is she anywhere on calle
rosa luxemburgo or in the colegio público rosa luxemburgo or
the clínica veterinaria rosa luxemburgo all of which are also in
madrid where you won't find her you will not find her on calle
rosa luxemburgo in arganda del rey it wasn't rosa luxemburg who
lit up the róża luksemburg electric lamp factory in warsaw she is
not in the jardins rosa luxemburg in paris or the jardins de rosa
luxemburg in barcelona where although you may find roses
you will not find her it's no use looking for mies van de rohe's
monument to rosa luxemburg and karl liebknecht in berlin as it's
no longer there but if it were you wouldn't find her and she's not
in rosa-luxemburg-platz in dresden or the collège rosa luxemburg
in aubervilliers knock on every door in ulitsa rozy lyuksemburg in
yecaterinberg she isn't there you will not find her she isn't on lôn
rosa lwcsembwrg in llandegfan nor in the lycée rosa luxemburg in
canet-en-roussillon you can spend days on ulica roza luksemburg
in skopje but you won't see her she is not on ulitsa roza luksemburg
in sliven you will not find her on calle rosa de luxemburgo
in la camocha you will not find her you will not find her there

GRAVEDIGGERS

JUST BECAUSE YOU'RE PARANOID, doesn't mean that they're not after you. We realised this too late, of course. Better late than never? We hesitated. We waited. Good things come to those who wait. But they didn't (come). Even though we did (wait). We closed the stable door after the horses had bolted.

<div align="center">✝</div>

So we took small measures. Measures of no mean symbolic force, but practically useless.

We refuelled the getaway car. We intercepted the message, once it had been delivered (and redacted all compromising information, once it had been read). We went to ground. We didn't tell the authorities. We warned one another. We built a bulletproof coffin.

<div align="center">✝</div>

I don't want to apportion blame. Let those without blame cast the first stone, and I am certainly not without that. A good worker doesn't blame their tools. I dug a grave with a wooden spoon, so I should know. I dug this grave with a wooden spoon. Unfortunately, this isn't a metaphor. Shortly afterwards, I planted a tree. When the tree's fully grown, I'll use a thick branch or two to make a handle. Then I'll mine ore. Smelt ore, extract metals. Form a head. Attach the head to the handle. Hopefully, the next time I need to dig a grave, I'll have a spade ready.

WHAT DR EINSTEIN?

BUT WHO WAS THE MYSTERIOUS 'Dr Einstein', with 'baldness at the temples', 'sideburns' but no moustache or beard', 'straight nose', 'big mouth', eyes that 'stand apart from each other and are of an indefinable grey', who 'wears a lorgnette or glasses with horn rims', and most disturbing of all, was 'committed to the communist principles'? Was there a communist Einstein in Berlin or elsewhere who actually fit this description?

Indeed, there was. The railway police in Bamberg, Bavaria, reported on 22 June, 1919, that they had 'apprehended [a] person, presumably Einstein [...] about 165 cm tall [...]; without beard, with sideburns, glasses, dark hair, bald on his forehead and the back of his head'. He also had 'a deep scar from surgery behind his right ear' and 'speaks slowly, calmly, and without an accent'. He had been stopped on 14 June at the Bavarian border while travelling on a train from Berlin to Nuremberg, and had identified himself with a false passport—a military identification card in the name of a certain Paul Karl Körcher, which had greatly alarmed the police officers: they believed they were facing none other than Max Levien, the fugitive leader of the Munich branch of the German Communist Party. Levien had been a prominent foreman of the short-lived Bavarian Soviet Republic (7 April to 2–3 May, 1919), and widely-circulated wanted posters had offered a reward of 30,000 marks for aid in his arrest. Levien's fellow Bavarian communist leaders had already been either killed or arrested. Nonetheless, neither Levien nor Paul Körcher had been apprehended: the railway police had indeed arrested Einstein— not Albert but Carl Einstein, author, avant-garde art critic, and radical revolutionary.

Carl Einstein also was the person the Dutch authorities had confused with Albert Einstein: Carl Einstein did live in Berlin on Uhlandstrasse (at number 32, actually only a few blocks away from Albert Einstein at Haberlandstrasse 5), and he indeed was

'consorting' with a countess, Aga von Hagen. But why would the Dutch authorities confuse a Berlin communist with the world's most famous physicist? The neutral Dutch had followed developments during the war in nearby Brussels closely, but what exactly had happened there that would have made them apprehensive about Einstein, Carl or Albert? What role did Carl Einstein play in the communist movement? Were there other occasions in which the two Einsteins were confused? By answering these questions, we will gain new insight into the wider reception of Albert Einstein and his theory of relativity.

THE 'COMMUNIST EINSTEIN'

At the end of the Great War, while Carl Einstein hastily departed from Belgium, Albert Einstein's name was circulating in the Berlin press in relation to various democratic initiatives in Germany. On 13 November, 1918, he gave a lecture at a public meeting that was attended by more than a thousand people and was prominently reported on. He spoke out in support of the November Revolution, but he strongly warned against a violent and undemocratic 'tyranny of the Left'. Albert Einstein thus stepped forward as a prominent voice in the political arena, but not as an anarchist revolutionary.

Did only Dutch officials confuse Albert and Carl Einstein? Or were there other times and places where they could be or in fact were mixed up? Albert thought so: in an interview in December 1919 for the *Neues Wiener Journal*, he stated that 'In various newspapers I am portrayed as an emphatic Communist and anarchist, obviously due to confusion with someone who has a similar name. Nothing is farther from my mind than anarchist ideas'. As we will see, Carl Einstein's continued and visible role in a number of revolutionary efforts would produce ample opportunities to tangle up the two.

On his return to Berlin in the middle of November 1918, Carl Einstein immediately entered the revolutionary fray. He published communist appeals, for example: 'To the intellectuals – One thing remains to be done: to make a communist society a reality', and he was involved in the violence that took place in the Berlin newspaper quarter during the Spartacist uprising.

At its conclusion, on 16 January , 1919, a day after communist leaders Rosa Luxemburg and Karl Liebknecht were murdered, the leftist paper *Freiheit* prominently reported on its front page the arrest of 'the author Carl Einstein', and claimed that it had taken place without any probable cause. Later, Carl Einsten was part of Berlin's brutal March battles (*Märzkämpfe*) which followed a general strike and involved summary executions by government-backed paramilitaries; afterwards he had to live as a fugitive, 'fleeing from house to house', in the words of artist George Grosz.

Carl Einstein's name surfaced again in the press in April and May of 1919 as he lectured at the second Congress of Soviets in Berlin. In the following month, just before he travelled to Bavaria, newspapers reported that Rosa Luxemburg's corpse had been recovered from a Berlin canal. Carl Einstein was one of six speakers at the ceremony commemorating her passing—a ceremony at which thousands were present. According to one account in the daily *8-Uhr-Abendblatt*, many Spartacists had spoken in an inflammatory manner at the event. The paper particularly singled out 'the communist Einstein' (note: identified without his first name), who would have tried to incite the crowd to 'pick up by surprise and kill', not only those responsible for Luxemburg's murder, but also those who had silently condoned it. Denials soon appeared in *Republik* and *Freiheit* from attendees, and from Carl Einstein himself: The *8-Uhr-Abendblatt* had given an entirely false representation of what had transpired; the faulty report had been due, according to Einstein, to an attempt to slander his name and that of other communists.

The events at the commemoration of Luxemburg resurfaced in a Munich newspaper that recounted the police apprehension of the 'communist Einstein'(note: identified again without his first name) near Bamberg. Carl Einstein had been on his way to Nuremberg to lecture at a political rally, but on 18 June, 1919, after his arrest and after the local police received confirmation of his identity, he was directed to return to Berlin. The Berlin press, in their accounts of his arrest, added to the story new twists ('Einstein would have loaned his passport to Levien') and turns (there

would have been a 'campaign against Einstein'). Most surprising was a new claim that Carl Einstein's supposed incitement at Luxemburg's graveside had been fabricated by press officers of a paramilitary *Freikorps* that, in fact, was under the command of those responsible for her murder.

After the most turbulent months of the Revolution of November 1918 had passed, Carl Einstein remained a prominent communist activist; at times, however, he would suspend his political agenda or revise his positions. He quickly became disappointed with developments in Germany, but persisted in a personal and artistic rebellion.

AN ORDINARY MOURNING

OUTSIDE THE BATHROOM WINDOW that frames the world, the sun is shining and the birds are singing. Einstein reminds himself that such things do not act in this way out of mockery. The sun shining bright has little to do with the affairs of Carl Einstein, or anybody for that matter. The sun shines as it has no alternative and it would shine bright even behind the darkest clouds. As for the birds, birds can sing at any time of the day, but during the dawn chorus their songs are often louder, livelier, and more frequent. It is mostly made up of male birds, attempting to attract mates and warn other males away from their territories.

Einstein stands before a cold mirror, but he cannot see his own reflection. He has emerged from a hot bath and the mirror has steamed up to such an extent that he thinks his figure and surrounding environment have become reminiscent of a half-completed Jean Arp painting. He is reminded of hearing a story the night before that Arp avoided conscription by moving to neutral Switzerland, and when asked to report to the German consulate he did so but completely naked.

Taking the towel that he tightly wrapped around his waist off he proceeds to wipe the condensation from the surface of the mirror. Einstein applies too much force to the mirror. The mirror is momentarily suspended in thin air before crashing with the full force of gravity into the ceramic sink. Shards of reflective glass shower down onto the tiled flooring, creating a cacophony of industrial sounds. The composition lasts the duration of a split second. Einstein stands motionless over the shattered mirror.

Einstein has considered writing extensively on the superstitions that surround reflections. He knows that mirror superstitions probably evolved from the time when the first humans saw their reflections in a pool of water. He thinks of how an unevolved human might confuse the image in the water with their soul and think that to endanger it would mean risking injury to the other self.

He knows from ancient myths that mirrors have magical powers, including the power to foresee the future and are thought to be devices of the Gods. Breaking a mirror would terminate its powers, the soul would be astray form the body, and misfortunes would be brought upon the one whose reflection it last held. Einstein's Latin teacher told him that it was the Romans who tagged to the broken mirror a sign of seven year's bad luck. The length of the prescribed misfortune came from the ancient Roman belief that it took seven years for life to renew itself. If the persons looking into the mirror were not of good health, their image would break the mirror and the run of bad luck would continue for the period of seven years, at the end of which their life would be renewed, their body would be physically rejuvenated, and the curse would be ended banished to the realm of memory.

Einstein remembers paying a shameful amount of money (although he cannot recall the exact amount) for the mirror, and that in times gone by, mirrors were not cheap, and they were low quality and easily defected. He knows that in order to avoid negligence it was told that breaking a mirror could bring seven years of bad luck. That was a simple scare tactic. Einstein momentarily longs for such ancient and primordial economic scare tactics that pale in comparison to the mindless propaganda that continues to engulf much of the nation he calls 'home'.

A variety of remedies are available to break the spell of misfortune. The Romans are also responsible for a little known measure for avoiding the curse useful for anyone who breaks a mirror. The luckless who accidentally break a mirror, and who do not wish seven years of ill-luck, must take all the pieces of the mirror and bury them in the moonlight, or take all pieces and throw them into running water, or pound the broken mirror into tiny pieces so that none of them can reflect anything ever again.

Some other remedies include lighting seven white candles on the first night after breaking the mirror and blowing them out at midnight in one breath, while another is touching a tombstone with a broken piece of the mirror to avoid the bad luck. Perhaps the easiest counter-remedy is to make the sign of the cross on a

one-dollar bill, but what is to be done with the one-dollar bill after that Einstein cannot recall, and besides, Einstein has never seen or held a one-dollar bill.

Einstein knows that if a person who breaks a mirror is too lazy or too busy, to avoid the curse, they must leave the broken pieces alone for seven hours (one for each year of bad luck) and then pick up the fragments immediately after the hours are up. And this is exactly what he decides to do. He thinks that the activity of tidying up may settle his restless mind after the funeral proceedings.

Drying the rest of his body Einstein leaves the bathroom, dresses, and retires to his living room.

Einstein is sitting in his living room writing in a small red notebook. He is struggling to articulate something. He is struggling to articulate everything. He thinks that struggling might bring him a reason, a purpose. But he found none, for when he dismembered his pain he found fundamentals, or, more precisely, metamorphoses, which were completely other than pain. He recognised struggle as a stimulus to joy, as an agreeable releasing, and then told himself that there was nowhere that struggle could be found, and the entire bestowing of reason was a laughable and naïve confusion, for the logical has nothing to do with this struggle. He thinks of how to begin writing. He thinks of the broken mirror still sitting in the bathroom sink. He wants to start by forgetting the broken mirror, releasing the sign from its symbolic, from its culturally determined bondage to meaning, to its unbounded potential in a playful relations of signifiers. He thinks and does not write.

A moment of fatuous rage falls over Einstein. If only broken objects could coalesce meaning in the same way that words do, and yet, they do. Writers Block. Surely, thinking in one way or another is writing? It would be clichéd to admit to being lost for words, he thinks. He thinks of the shape of the word 'cliché'. The word 'cliché' does not derive from any Latin word or even any previous Roman or French word. Einstein recalls, as legend has it, that a group of printers back in 1800s' France got the idea to save time by forging common phrases onto a single plate instead of writing out every line of text word-by-word. In English, these

plates are referred to as stereotypes. To utter a cliché, one is saying something that is so unoriginal that there's actually a prepared mould to represent it. And when one unjustly 'stereotypes' a person or race, what one is really doing is forging them onto a French printing press plate. Einstein feels his body grow heavier. There is no way to represent this violence. There is no way to represent this grief. There is no way to represent this anger. He thinks and does not write.

Einstein knows that the best way to write is to read and so he takes Rosa's book into his hands and begins to read aloud. Clearing his throat, he speaks the words that for so long he has taken for granted. Einstein stands up and speaks: 'If it is true that theories are only the images of the phenomena of the exterior world in the human consciousness, it must be added, concerning Eduard Bernstein's system, that theories are sometimes inverted images.'

Without warning Einstein begins crying and collapses back down into his chair. Taking out his pocket watch Einstein realises that he must leave immediately. He knows that he is expected to speak but he does not know what he will say. He takes his pencil and writes into his notebook. He cries and begins to write.'What does a broken mirror look like?'

'THE LANDWEHRKANAL WILL NOT STOP'

NEAR THE BEGINNING OF *The Art of the Twentieth Century*, Carl Einstein writes that '*das klassische Maß war zu Mäßigkeit und Mangel an Begabung verkommen*'.[1] Roughly, the classical sense of measure had degenerated such that it now enforced a 'frugalness' and 'deficit' upon talent. The answer to this problem had to be found, he will argue in the following pages, through the invention of new concepts of measure and new modes of art. This apparent turn to novelty must be differentiated from a history of art which ties the transformations of style to a continually transmogrifying art market. In this latter view, stylistic change is continuous with an advancing capitalist commodification. Artists develop new styles to satisfy the interest of collectors who pursue art as an investment in capital, both conventional and cultural. This view brackets the question of style's, and indeed of form's, relation both to the history of art and to the world in which art exists; even worse, it belies the possibility of style and form holding onto something like 'truth'. For Einstein, the task of artistic style was precisely to account for the new conditions of aesthetic representation in a world when ossified historical notions appear to have lost their expressive faculty. The task of art in the twentieth century is not to develop novel, interesting looking commodities, to be stored on walls or in safes. Nor should the art merely embrace a novelty unencumbered by history. Instead, art must bear both the weight of the past and the burden of the present. Only by taking this on, can art become adequate to the demands of its moment, without falling into superficiality or repetition compulsion. The revolution demanded by the history of art must be so total and thoroughgoing that it does not end with art's present, but revolutionises the capability of comprehending the past as well. The history of art must be resurrected, not through imitation, but through fundamentally reshaping the conditions of representation of the future.

Karl Marx, too, knew that 'the tradition of all the dead weighs like a nightmare on the brains of the living', a line that applies to politics no less than the history of art.[2] Yet what does one make of this line when standing beside a grave and when speaking to the recently dead. What does one do when the dead are Rosa Luxemburg, and her memory is not a nightmare. To bury her was not only to bury the dead, not only the past, but also the future. With the death of Rosa Luxemburg, it seemed, it seems, that a possible future also died. How does one hold an oration, speak to, speak on behalf of, speak about someone not realised, or something not realised. One might more easily pose the task thus: The only funeral oration suitable for Rosa Luxemburg is one that can reanimate the dead.

22/23 December 1967 in Berlin just over forty-nine years after Rosa Luxemburg was murdered, Paul Celan attempted to speak to the dead, in his untitled poem *Du liegst*, a poem famously expounded by Peter Szondi in essay entitled 'Eden'. The poem and the title of Szondi's essay refer to the hotel where Luxemburg and Liebknecht were held before their murder, a hotel they visited. Celan's final version of the poem, following significant revisions, commences with a list of images: 'great auricle/groved round, snowed round', '*Spree*... Havel', 'butchers' hooks', 'impaled Apples/from Sweden', and then a sudden shift: 'The table with gifts comes/it turns around an Eden//The man became a sieve, the woman/must swim, the sow,/for herself, for no one, for everyone—//The Landwehrkanal will not sound./Nothing/stops'.[3] As we know from Szondi's essay, the images from the first half of the poem refer to Celan's contemporary experiences in Berlin, and they are seemingly banal ones largely gleaned from a Christmas Market. The images in the second half—Liebknecht gunned down, Luxemburg's body thrown into the Landwehrkanal—occur in the same place as the first, but not in the same time.

This is not an elegy, although, along with 'art' and 'oration', that term has been on the forefront of my mind while writing this. It is not a lamentation, but rather, a poem that express in

words particular sensory experiences, and these experiences are quite normal strolling around the Kurfürstendamm in December, even today. The expression of these sensations does, to a degree, bring them to life. As we have known since Orpheus, the lyric has particular affinity to the dead. 'Eden' interrupts the text, detourning it temporarily into a past that is not past, from the banality of the quotidian to the undead that haunt Germany's post-fascist present. Eden appears as an image that restages the fall—of social democracy, of liberatory communism, and, indeed, of the modernist enterprise that believed in the possibility of utopia. Human history begins in Eden, as any reader of Milton or Benjamin knows. What remains an open question in Celan, in Benjamin, in Einstein, and—most of all—in Rosa Luxemburg, is how it ends, is whether a new measure can be found. This remains open, for: 'The Landwehrkanal will not sound./Nothing/Stops'.

NOTES

1. Carl Einstein *Die Kunst des 20. Jahrhunderts*, Leipzig: Reclam, 1988, 5.

2. In Karl Marx (1852), *The Eighteenth Brumaire of Louis Bonaparte*, in MEGA I/11, 1985, 96–189, here 97.

3. Paul Celan, *Du liegst*, *Historisch-Kritische Ausgabe*, 1994, volume 10.1, p. 12.

EINSTEINROSARAUSCHEN

[*Very white noise, intermittently interrupted by a blur of voices*] ...dieses Geschlecht wähnte, aus geistigen Formulierungen Paradiese hervorzuzaubern. Es glaubte, man könne Tatsachen durch Bilder widerlegen. Tatsächlich berühren sie das zwingend Faktische, nämlich das Kollektive, nicht mehr. Wir bilden Ideen, dichten Märchen oder malen Bilder, doch wir sind die ersten Düpierten unserer Werke. Hier springt die peinigende Frage auf, ob das Poetische nicht schlechthin eine Regression darstellt und immer von schwachen Typen, die keine Wirklichkeit ertragen, gefordert wird. Alle Kunst enttäuscht, wann sie dem Dasein verglichen wird... [*sound interruption*] ...nach dem Kriegsausbruch glaubte kaum noch Einer dem blendenden Märchen... [*noise as before*] ... dass Fantasie zumeist eine ungeheuerliche Schattenbildung der Toten ist, dass Imagination, wann sie asocial erlebt wird, Flucht verrät, und an ihr das Reale abstirbt. [*voice trails off*] ...in der Entwertung des Wollens liegt eines der schweren Vergehen der Intellektuellen. Diese theoretischen, ängstlich schwachen Typen verteidigen sich gegen die Woge der Tatsachen und Erfahrungen durch sadistische Vereinfachung, nämlich hemmungslose Verbegrifflichung. Jede begriffliche Formulierung kündet ein Sterben, das Ende des lebendigen Prozesses an... [*loud clicking sounds*] ...eine proletarische Ideologie kann deshalb keinen Selbstzweck besitzen, sondern muss den Tatsachen koordiniert sein. Geist kann nur noch als koordinierte Kraft begriffen werden. Jetzt sind alle Gedankengänge Laufgräben... [*massive interference*] ...sociale Revolutionen vernichten abseits gezüchtete Individuen, da jene neue Übereinkünfte und Typen hervorbringen. Unser Lebensgefühl entströmt der Spannung des konkreten Chocs... [*overlay of clicking noises and blurred voices*] ...in jedem wahren Leben gibt es die Stelle, an der es den, der sich dareinversetzt, kühl wie der Wind einer kommenden Frühe anweht. Rosa Luxemburg erlag von feiger Hand gemordet. Ich hatt' sie lieb [*breaks off*]

Envoi à une raison

Waisen sind wir, ins große Gelausche abgesunken aus den Käfigen warmer Klugheit. Die Gräser fliehen von unsern Lippen. Regen gleitet fern von unsern kühlen Mänteln. Mich hält nicht mehr die Ranke des Einsteinerns mit überwachsener Mauer. Ich zerschlage mir den Kopf und meine Scherben überspülen die Mauer wie kurzer Regen.

DEAR ROSA

I'M SORRY TO SAY a century has drawn a perfect circle in time and in space in the hundred years since you died. I wish I could say your work has been completed by now. Imagine what the world could look like then. We're lucky your work is still unfolding. But for the moment I'm standing in London in 2018 and around me the antagonisms and vitriol that led to your murder a hundred years ago are being muttered and sputtered anew.

It's surprising. Between then and now, history had got worse and history had got better. Right now though, at this point in time, this city feels febrile, chaotic. Today newspaper headlines speak of the British government's preparation for emergency conditions if the country leaves the European Union in March next year with no deal. This making of union was an attempt at stopping the devastations that the Europeans unleashed on one another for centuries. Now Britain is readying itself for war conditions with a perverse nostalgia for real-wartime rationing. We're idiot children with a proxy war playing in our heads.

You were right. There will never be an end to these fantasies, there will never be an end to war until there's an end of capitalism. Money makes the world go round. War makes the money go round. Deal. No deal. As I walk along the streets there's a muttering call for money. It's a real call. In doorways and empty shopfronts people are living in the street again, asking for change.

I cross the road towards Trafalgar Square and a woman hands me a leaflet. It's a message from the Women in Black. The headline reads NO TO VIOLENCE. I catch the eye of one of the silent protesters. As I walk on I think how unfamiliar it has become to share a moment of solidarity with a stranger.

Of course I've lived through tense times like these before. When I was the age you were when you organised your first general strike the world seemed to be divided into two halves. The side in which I lived was run by war-mongers. I remember

feeling afraid quite often. I'd listen for any possibility for change. I wasn't like you. I didn't yet know how to act to make things better.

At school we were taught that history is like a record, a long-playing record but one where the needle's stuck so the record keeps playing the same loop over and over again forever. Our teacher told us revolution is the moment when someone nudges the long-playing record of history so the needle can jump out of the groove it's been stuck in and can hit a different track.

This is how life happens. It comes with the sprung energy of surprise. However much we make emergency preparations, the real truth of life comes in moments of inspiration. Chance. An open gesture. The possibility of communication.

So I'm thinking of the moment when I'm standing outside a small one-screen cinema, the very cinema where Wittgenstein had learned to love film. I'm watching the cinema manager put up a new film poster. He unrolls it and I see it's for a film version of your life by a director that I don't yet know but who will change how I think about cinema with her own revolution in film. A handshake across time between women. What I'm remembering now is seeing that image unfurl. There is your name written across the poster above the handsome intelligent face of the actress playing you in the film. Rosa. Luxemburg. I read the title. I don't yet know who you are.

This was the door that opened to let me think what resistance could mean.

Thirty years later and I'm a filmmaker. Unlike you I chose film rather than writing as my mode of discourse. The scale seems suited to the spectacular times I inhabit. Words and images are being undermined daily by politicised attacks on the notion of truth. You'll know all about this. The tumbling unreality propaganda creates.

It's disheartening. Life brings enough uneasy unreality on its own. I'm writing this for a book that is also remembering Carl Einstein. When he gave his oration at your graveside he was reported in the press by some people as Albert Einstein. So there you are: life's unreality right there. Dadaism in action.

Those lazy journalists missed who this Einstein was. What a loss for them. A man who understood that the European imagination could be opened enough to read art differently, who could see, at a time when the African continent still meant the greedy hand-rubbing of colonial opportunism, that art made in Africa could open our minds to a way of thinking where provenance accounted for migration, where aesthetics could invite very different refinements. Revolution in thought. Revolution in art. Revolution in education. Revolution in action. An invitation.

On it goes. As I stand in the middle of London all its possibilities swirl around me on a rainy weekday night busy with end of day crowds. Next to me the small-island imagination that the crowds are supposed to share waves from a big screen TV in an office lobby, empty, with its own ghostly unreality. A ticker-tape of news feed on the bottom of the screen narrates what's happening above in image. Poor image. This isn't what an image was made for. An image can save a man like Wittgenstein from his immigrant isolation. An image can move ideas between continents. I look at the lobby. This isn't what architecture is for. All the people sleeping along the Strand could sleep in that emptied space tonight.

This world isn't good enough.

Imagine opening the doors. Imagine the opening of culture's imagination. Imagine skipping the needle to the next track. Imagine being sixteen and thinking to start a strike.

Imagine the circle opening.

Imagine.

Dear Rosa, everything is possible. Was. Is. Shall be.

A handshake across time.

LOVE AMONG THE SAILORS /
DON'T ASK ME FOR WORDS
(Laurie Anderson / Eugenio Montale)

THERE IS A HOT WIND BLOWING
It moves across the oceans and into every port

A plague
A white plague

There's danger everywhere
And you've been sailing
And you're all alone on an island now

Tuning in

Did you think this was the way
Your world would end?

Come with us to the mountains
Sisters. Sailors. Comrades

There is no pure land now.
No safe space
And we stand here on the pier
Watching you drown

Don't ask us for the word
To define our shapeless spirit
And announce it in burning letters

There is a hot wind blowing
And plague drifts across the oceans
And men walk obliviously
Friends to themselves and others
They haven't noticed that a blazing sun
Casts their shadows
On crumbling walls

And if this is the work of an angry god
I want to look into his angry face

Don't ask us for a phrase
Even a few gnarled syllables
There is no pure land now. No safe space
Only this is what we can tell you today

That which we are not
That which we do not want

SPARTAKUSBRIEFE
(GELBE WESTEN) 16/11/18–6/12/18

16 November—The so-called *Gelbe Westen* (yellow vests) protest movement has no official organisation, no identified leader, and no political affiliation. As a result, the authorities fear the location of protests is almost impossible to pin down and nobody has a clue how many people will turn up.

17 November—Demonstrators from the *Gelbe Westen* movement have called for people to turn out to gridlock the road network to show their anger. The scale of the spontaneous popular revolt revealed an unexpected level of public discontent with authorities accused of being out of touch with the problems of ordinary people.

18 November—The *Gelbe Westen* citizens' movement—named after the protesters' fluorescent, high-visibility vests—has caught the authorities off-guard. The movement has no leader and it is constructing *ad-hoc* barricades at tollbooths, roundabouts, and fuel depots.

19 November—227 protesters were injured, the majority of injuries caused by drivers attempting to force their way through blockades; one sixty-three-year-old woman attending the *Gelbe Westen* protest was killed after a driver 'panicked' and accelerated into protesters. 117 people were arrested and 73 were later taken into police custody. Police deployed tear gas to disperse blockades.

20 November—The *Gelbe Westen* protests are continuing into their fourth day, as the Minister for the Interior condemns the movement as 'no longer coherent'. On Tuesday 20 November, protests were still continuing after the largest day on Saturday 17 November, with a number of motorways and petrol stations still blockaded.

21 November—Drivers were stranded overnight by *Gelbe Westen* blockades on the A10, it was reported as the protests entered a fifth day with no end in sight. The number of protesters taking part has dwindled since the first blockades on Saturday, when nearly 300,000 people manned barricades and took part in other forms of protest. On Tuesday, that figure had dropped to 20,000. After taking a light-handed approach to policing protests at the weekend, police have increasingly taken a tougher stance. On Wednesday, the Interior Ministry said road blockades at some thirty strategic sites had been cleared since Monday, including those set up at fuel depots.

22 November—By Saturday night the barricades had been burned, windows in the area had been smashed and traffic lights had been uprooted. 130 protesters were arrested; 19 civilians and 5 police officers were injured in the confrontations. The *Gelbe Westen* marches, referred to as an 'insurrection' on television, have garnered the support of around eighty per cent of the people. The president's support is at an historic low of twenty-six per cent, with critics saying his government prioritises the needs of the wealthy and businesses over those of rural and low income citizens.

23 November—Two people have been accidentally killed and more than 530 injured, 17 seriously, in a week of protests and roadblocks over what one thirty-year-old factory worker who has been attending roadblocks called 'a broken society where we're counting pennies to reach the end of the month, sick of politicians who don't give a damn robbing the poor to give to the rich'.

24 November—What was supposed to be a peaceful protest by the *Gelbe Westen* movement has degenerated rapidly. On one side, protesters reportedly infiltrated by far-right extremists and rioters and hooligans tore up paving stones and hurled them and other missiles at police before building barricades that they set alight. On the other, police used teargas, pepper spray, water cannon, and bulldozers to clear the road. Each time the police advanced, protesters rebuilt the barricades, using metal barriers from roadworks and construction sites, rubbish bins

and anything else they could find. Many *Gelbe Weste* attempted to withdraw as violence erupted, but were hampered by advancing police. Others retreated, but vowed to remain at the protest.

25 November—The number of protests appears to be decreasing. Estimates suggest that over 106,000 people came out to protest on Saturday, of which 8,000 were in the capitol. This is just over a third of the number—over 282,000—who came out in force nationally last Saturday 17 November, the main day of blockades.

27 November—In a rare display of humility and deliberate empathy with the anger among voters living outside the big cities, the president said his administration needed to be smarter in its policy making to avoid a 'two-speed country' emerging, where workers in outer-urban areas felt left behind. 'I have seen, like many ordinary people, the difficulties for people who have to drive a lot and have problems making ends meet at the end of the month,' he said.

1 December—The Government considers state of emergency over the *Gelbe Weste*n protests. At least 100 people have been injured in street battles, with cars torched and shops raided. Masked protestors burned barricades, set fire to buildings, smashed fences, and torched luxury cars on some of the most expensive streets in the city as riot police fired teargas and water cannon.

2 December—Government buildings were set alight as protesters threw 'Molotov cocktail-style projectiles', while around 30 people were injured in scuffles. Government officials have responded: 'There is a strategy being managed by professional rioters, who are seeking to smash things. I say to the *Gelbe Westen*, do not let yourself get caught up in this, protect yourselves, protect the people, protect our heritage. Do not take part in these factions', adding later: 'Those responsible for violence want chaos. I will never accept violence. No cause justifies attacks on police or businesses, threats to passers-by or to journalists, or that the cities monuments be damaged'.

3 December—Police call for army to help quell riots amid warnings of pre-revolutionary unrest. The police unions' plea

came as the government held crisis talks with the leaders of all political parties, many of whom urged the president to instantly scrap 'green' fuel tax hikes to avoid the country spiralling into a permanent state of insurrection. The three-week revolt has exposed a deep malaise over high taxation, the price of living and a sense of social injustice. Much of the ire has been directed against the president himself with many protesters complaining he is an arrogant and out of touch 'president of the rich'. High-school students—who have been protesting against changes to colleges and the university system—also seized on the mood of protest and stepped up their blockades. About a hundred high schools were fully or partially blockaded around the country. Seven teenagers were arrested after riot police were called when a car was overturned and bins were set alight.

4 December—The concessions made by the government today, do not appear to have appeased the *Gelbe Westen* protesters, who have vowed to continue their protests, prompting a series of cancellations and postponements, including—currently—two top-flight football matches, and a number of charity events. Even an annual Telethon event in Paris is under threat.

5 December—Police and a hard core of rioters on the fringes of the *Gelbe Westen* movement continue to play games of cat-and-mouse in two or three areas of the capital. Most of the peaceful demonstrators have now left the capital, and marches are winding up in other cities too. Riot police backed by an armoured vehicle charged a last group of protesters just after nightfall after a day of confrontations and unprecedented police efforts to prevent new violence. Police and local authorities estimate some 31,000 people took part in Saturday's demonstrations, including around 8,000 in the capital and 2,000–3,000 in other cities.

6 December—Yellow spray paint graffiti on a grey granite wall of an exclusive store front in the expensive district of town reads:

'WE WANT MONEY WHILE WE WAIT FOR COMMUNISM!'.

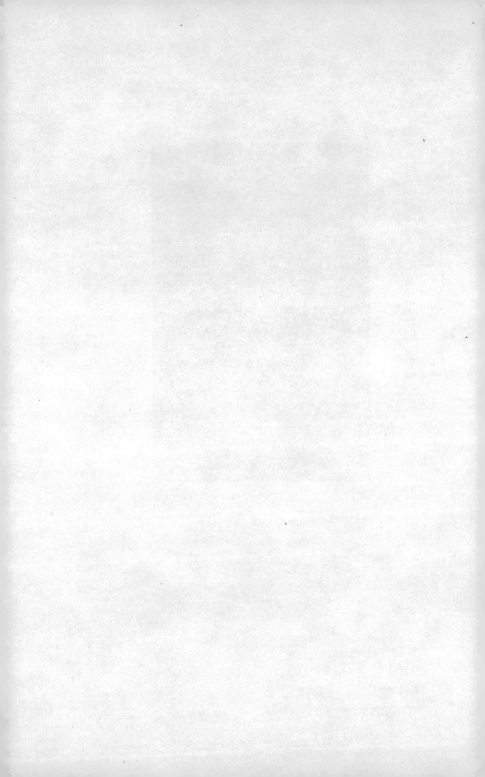